HIDDEN
HISTORY
of
DUBUQUE

Susan Miller Hellert

THE
History
PRESS

Published by The History Press
Charleston, SC
www.historypress.net

Back cover, inset: *Center for Dubuque History, Loras College, Dubuque, Iowa.*

First published 2016

Manufactured in the United States

ISBN 978.1.46711.859.0

Library of Congress Control Number: 2015956832

To my father, whose stories inspired me.
To my mother, who urged me forward.

CONTENTS

Introduction 7

1. In the Beginning 9
2. Fact or Fiction on the Mississippi 15
3. Lead Brought Them 21
4. Black Hawk, Lead Lust and Law and Order 29
5. The Little Maquoketa River 37
6. Parks, Picnics and Tragedy 51
7. Ministers, Priests and Bishops: Conversion of a Frontier 65
8. Strong-Minded Women 75
9. Memories from Dyersville 85
10. Civil War, Economic Panics and Lumber to the Rescue 99
11. A Cascade on the Maquoketa River 109
12. To Drink or Not to Drink 117
13. Where? Who? What? 125

Bibliography 141
About the Author 144

INTRODUCTION

D ubuque County, Iowa, is located within the Driftless Region along the Mississippi River. During the last glacial age twelve thousand years ago, no glaciers scoured or left deposits in the Driftless Region of the Midwest. The city of Dubuque is located at the confluence of Iowa, Illinois and Wisconsin. Geography has played an inescapable role in its history.

The Mississippi and its tributaries allowed for exploration, as well as the transportation of goods. The lack of glaciation made mineral deposits of lead and zinc accessible. Rich soil brought farmers. Farmers and miners brought families. Families meant schools, churches, homes, businesses, roads, railroads and civilization to the frontier.

The stage was set for the Key City to play a dominant role in local, national and even international history. This book will tell the stories not so well known. Mysteries solved and unsolved, fortunes lost and found, famous and infamous residents, buildings destroyed and buildings saved, settlements expanded and settlements abandoned will be discovered.

History, hidden or not, is a collection of memories. Myths and facts sometimes blend to become those memories. This book intends to entertain, educate and bring those memories to life.

Enjoy!

IN THE BEGINNING

G laciers, burial mounds, disappearing towns, the Northwest Passage, river monsters, lead and iron cooking pots all merged to form a unique beginning.

About five hundred miles to the north of Dubuque, Iowa, the Mississippi River begins its journey to the Gulf of Mexico from Lake Itasca, Minnesota. This Great River, as the Ojibwa named it, drains the area from the Rocky Mountains in the West to the Appalachian Mountains in the East, making it the third-largest drainage basin in the world; only the Amazon and the Congo are larger. It makes up part of the borders of eight states, including Iowa. A raindrop falling into Lake Itasca takes only ninety days to reach the Gulf of Mexico.

The Mississippi continues on its journey south, intersecting with the Wisconsin, Missouri, Ohio, Tennessee, Arkansas and Red Rivers, along with many smaller tributaries. Dubuque's location south of the Wisconsin River but north of the other major tributaries made it an important transportation center for the Upper Mississippi Valley.

The Mississippi River resulted from the melting glaciers to the north, west and east of the Driftless Region. Dubuque, located in this region, benefited from the lack of glaciers because the landscape remained hilly without tons of glacier debris burying the natural mineral resources. To the west and east, these retreating glaciers left silt to dry and blow across the landscape of the Midwest, forming rich topsoil, or loess, for a farmers' haven. The Mississippi River supplied accessible and manageable transportation for lead and later farm produce to a world market, while roads proved impassable or simply nonexistent.

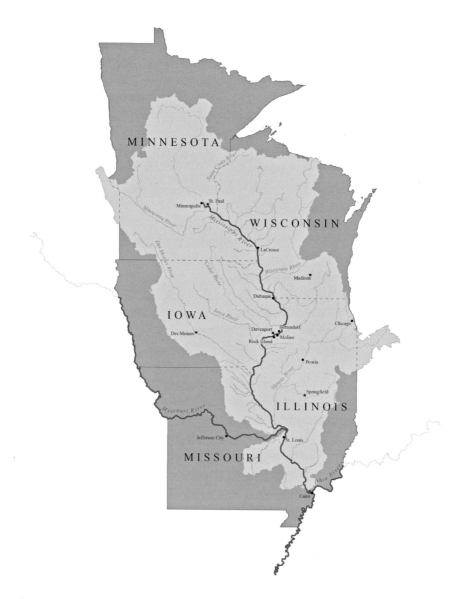

Mississippi River Watershed. *Courtesy of Upper Mississippi River Basin Association.*

Once the glaciers disappeared, man arrived. A succession of Native American people occupied what is today Dubuque. The Mound Builders left unmistakable evidence of their presence. North of Dubuque, near Marquette Iowa, Effigy Mounds National Monument contains over two hundred mounds in a variety of shapes built by the Late Woodland

Indians (1400–750 BCE). Earlier groups built simpler mounds in a linear or conical shape, but the Effigy Builders also built mounds in the shape of animals, such as birds, bear, deer, bison and turtles. The conical mounds were sometimes used as burial mounds, but the effigy mounds seemed to be ceremonial or territorial markings. The culture and motives of the Mound Builders remain a mystery.

To the north of the city of Dubuque, near Sageville, Iowa, the Little Maquoketa River Mounds State Preserve protects thirty-two conical burial mounds. These mounds are thirteen to thirty-two feet across and six and a half to fifty feet high. The view of the Little Maquoketa River Valley is exquisite, but the stairs mounting this two-hundred-foot-high bluff are daunting. We can only imagine the commitment made by these early people to construct these mounds with thousands of bushels of dirt carried from the valley floor.

While people recognize the Great Pyramids of Giza, or the mysterious Petra, few recognize Cahokia, the largest of these Mound Builders' settlements. Built east of the present site of St. Louis, Missouri, Cahokia was the largest city in North America until Philadelphia surpassed its population of forty thousand in the 1780s. During the thirteenth century, these and the other Mound Builders abandoned their towns and villages. They disappeared into the surrounding region or migrated to other areas.

Prior to European exploration, these Mound Builders disappeared. The causes of their disappearance were most likely varied, but the real reasons for leaving are shrouded by mystery. Perhaps overpopulation, warfare, climate changes affecting food growth, disease or dissatisfaction with the existing culture brought about its demise. We will probably never know.

Little Maquoketa River Mounds. *Author's collection.*

11

Following the disappearance of the Mound Builders, the Oneota prehistoric culture arrived on the scene. The Ioway, who called themselves *Paxoche* or "ashy or dusty heads" due to dust blown from the earth or campfires, and Otoe people lived in what is today Northeastern Iowa. These groups were driven out by the Santee and Yankton Sioux, who were in turn driven out by the Mesquakie or Fox and Sauk Indians as they migrated west from the St. Lawrence River Valley and Ontario due to war with the Huron. Other native groups to arrive in northeastern Iowa included the Omaha, Osage and Kickapoo. When the Europeans and, later, the Americans learned of the lead and rich farmland, these other native groups were also driven out by the new arrivals to Northeastern Iowa. Immigrants all.

The lead left unburied by the glaciers lured Nicolas Perrot to the Dubuque region in the 1600s to supply a world hungry for lead ammunition. Father Louis Andre, a Jesuit priest, and Michael Accault also visited the Ioway to bring Christianity or trade. The Ioway had long specialized in the bison hide trade.

France, having heard of the riches available along the Mississippi River, sent Jacques Marquette, a Jesuit missionary and linguist, and Louis Joliet, an experienced map maker and geographer, to explore the unknown and determine if this great river led to the Pacific and the much-sought Northwest Passage to the Far East. They left Green Bay on the shores of Lake Michigan on May 17, 1673, traversing first the Fox River and then the Wisconsin River after a short portage near present-day Portage, Wisconsin. On June 17, 1673, "with a joy that we cannot express," they arrived at the Mississippi River. South of the confluence, they spotted "iron" mines along the banks and a monster in the water with the "head of a tiger, nose of a wild cat, and whiskers." The mines were lead mines, and the Mississippi River catfish inspired tales of monsters capable of overturning canoes.

They found no Northwest Passage to the Orient, but they did describe the riches of the region to inspire more French exploration and the eventual French claim to all the land along the Mississippi River and all its tributaries—a claim that eventually conflicted with the Spanish and the British.

Between 1712 and 1737, the French (assisted by various groups of Indians) conducted a series of wars against the Mesquakie. They had encountered the Mesquakie along the Fox River in Wisconsin. Frustrated by the Mesquakie interference in their trade, the French attempted to exterminate them. The Mesquakie and their Sauk allies retreated across the Mississippi into Iowa, where they established villages along

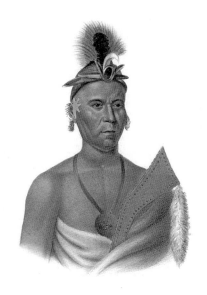

KEE-SHES-WA.
A FOX CHIEF

Left: *Kee-shes-wa, a Fox Chief*. Painting by Charles Bird King, lithograph by J.T Bowen. *Wikimedia Commons*.

Below: *Père Marquette and the Indians*, by Wilhelm Lamprecht (German 1838– 1906). *Wikimedia Commons*.

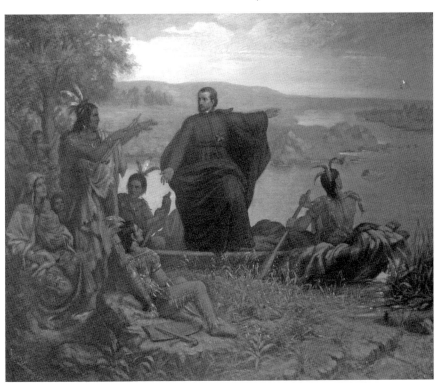

the Turkey River, at the lead mines along the Catfish Creek (Dubuque) and to the south. Unable to accomplish the genocide of the Mesquakie, France granted them a pardon in 1737.

Galena, or lead, had long been a trade item for the Indians in the Dubuque area. Trading lead as far away as the Rocky Mountains and the Gulf of Mexico, they used it for beads and paint. Julien Dubuque, for whom the town was named, arrived at the lead mines along the Catfish Creek from Prairie du Chien via Green Bay and French Canada. He secured lead mining rights from the Mesquakie in 1788. In 1796, he received confirmation of these rights from the Spanish governor. He wisely referred to the area as the Mines of Spain to secure this confirmation. Dubuque built his operation at Kettle Chief's village near the mouth of the Catfish Creek. His cabin and farm were located farther upstream. Prior to its destruction after Dubuque's death, the village contained at least seventy buildings.

With the arrival of French Canadians and their trade goods, the Indians rapidly became dependent on these goods. Iron, horses, wheels and guns improved their standard of living. Utensils made cooking much easier, horses improved transportation exponentially and guns allowed them to hunt and defend themselves much more efficiently. Dubuque and its surroundings would never be the same.

Chapter 2

FACT OR FICTION ON THE MISSISSIPPI

REVERE OF THE MISSISSIPPI

"The British are coming! The British are coming!" Jean Marie Cardinal, alone in his canoe, paddled from the Dubuque lead mines to St. Louis to warn the town of a British attack coming down the river in 1779 after Spain declared war on Britain during the American Revolution. While it might make a great story, it remains a myth. Cardinal did live in Prairie du Chien as one of its first settlers. His widow remained there after his death. The residents of St. Louis did repulse the British attack. Cardinal did die in St. Louis. However, Cardinal and a partner were on the run from a murder charge and unable to return to Prairie du Chien, Wisconsin; therefore, warning St. Louis of the British leaving Prairie du Chien for St. Louis was impossible. So, who provided the warning? A woman named Leson apparently is the real hero. As stories go, which is the more exciting: a lone frontiersmen paddling ahead of an attacking army to warn a town just in the nick of time or a settler's wife who noticed one thousand British troops coming down the river and warned the city?

COONSKIN CAPS AND FIRE ON THE WATER

Julien Dubuque, born in 1762 about fifty miles from Quebec, Canada, to French parents, arrived in Prairie du Chien in 1785. While trading with

the Indians there, he learned of the rich mines of lead near the village of Kettle Chief on Catfish Creek. In 1788, he persuaded the Mesquakie (Fox) to give him the right to work the mines. He cleared several acres, planted corn and built a cabin, a mill and a smelting furnace. In 1796, he petitioned the Spanish governor, Baron de Carondelet, and received a land grant to the Mines of Spain. The land grant extended seven leagues, or twenty-one miles, along the Mississippi River and three leagues, or nine miles, inland.

Julien Dubuque has often been pictured with a Daniel Boone–style coonskin cap and buckskin clothing. It was believed he set the river on fire to scare the Indians into supporting him. To further his godlike image, he supposedly could survive rattlesnake bites. Really? No!

Dubuque was a businessman first and foremost. He lived in style on the frontier. The Indians mined the lead, and Dubuque traded the lead to St. Louis. He was a gentleman farmer who was well known in St. Louis society. His extensive library and fine furniture were brought to the wilderness at great expense. His fiddle-playing ability and love of a good time were widely known and appreciated. Popular with the Indians, he did not need to frighten them with supernatural feats. They did allow him and no other to mine the lead, but this was the result of his treatment of them and generous gifts offered. When he died on March 24, 1810, his debt was huge. The considerable debt was evidence of his generosity.

The Chouteau family in St. Louis carried his debt. After his death, the Chouteau family sued for ownership of the Mines of Spain. The situation continued and became so severe that even after Iowa became a state, the ownership of the land within Dubuque's Spanish land grant was disputed. The U.S. Supreme Court decided in 1853 in *Chouteau v. Molony* that the Chouteau family had no claim on Dubuque as Julien Dubuque had not owned the land but only had the right to work it. Clear title to the land alleviated ownership problems that had resulted in residents refusing to pay their taxes.

Princess Potosa, the daughter of Chief Peosta, married Julien Dubuque—or did she? No evidence exists to support this story. Letters do indicate that a Madame Dubuque existed, but her identity has never been discovered. While it was common for the French fur traders to marry into local native communities to obtain trading rights and protection, just who Madame Dubuque was remains a mystery.

Julien Dubuque was buried by the Indians in a log mausoleum with tribal honors on a bluff overlooking the Mississippi River. Vandals disturbed the grave repeatedly. A daughter of Jenks Dexter, an original settler in Center

Julien Dubuque grave monument. Photograph by Bill Whittaker. *Wikimedia Commons.*

Township, Dubuque County, gained notoriety for possessing the jawbone of Julien Dubuque. By 1897, it was obvious more permanent burial measures needed to be taken. The City of Dubuque built a circular monument of native stone on the bluff, replaced Dubuque's bones in a native walnut coffin and covered the grave with generous amounts of cement. A grill over the doorway of the monument further keeps vandals at bay. Now a part of the Mines of Spain Recreational Area and E.B. Lyons Interpretive and Nature Center, Julien Dubuque's grave overlooks the mouth of Catfish Creek and the ancient site of the Mesquakie village. The Recreational Area encompasses 1,380 acres and is now on the list of National Historic Landmarks.

GOLD IN THE HILLS

Thomas Kelly, born in King's County, Ireland, in June 1808, migrated to Canada in 1826. From there, he moved to Oswego, New York, where he worked on the construction of the Oswego Canal. He later moved to New Orleans to earn money and planned to eventually return to Canada.

Robbed of his gold while on the Ohio River on his way back to Canada, he instead traveled to the Galena lead mines via St. Louis in 1830. In 1831, after learning the business of mining, he began his own operation in what was then Michigan Territory and is today Wisconsin. He lived alone in a cabin near Sinsinawa Mound and helped others to build a fort there. He surveyed the landscape, and by the spring of 1832, he had illegally crossed the Mississippi River to the Dubuque region. This was a common adventure for miners, who stayed until removed from the Indian Territory by the U.S. Army.

After being removed, he traveled to Scales Mound, Illinois, for the winter. In 1833, he returned to the Dubuque mines after the Black Hawk War caused the cession of the mining region to the United States. He failed to find lead at first, but on "Kelly's Bluff," overlooking the river at what he believed to be the site of the old "Indian Diggings," he hit a heavy vein of lead. He claimed approximately thirty acres and continued to work his claim.

His sister and brother joined him in 1836. A smelting furnace built in 1837 added to his operation. He opened a large area bordered by present-day Third Street, as well as a rock shaft north of Fifth Street. He lived frugally, planted a garden and worked every day.

Many stories surround Thomas Kelly and the immense gold profits from his lead mines. He distrusted banks, preferring to bury his gold. It is said he once occupied a cabin in Dunleith—now East Dubuque, Illinois—but while he was absent, a family took residence. When he returned, he waited until only the woman was present and then came to request a drink of water. While she was fetching the water from a spring, he quickly dug the gold from under the floorboards. When the woman returned with the water, he thanked her for taking care of his gold and returned to Dubuque.

While in Albany, New York, on a return journey to Dubuque with gold from the sale of his lead, he shot and killed a man in a robbery attempt. There are several stories of this event, and none has been verified. The end result was that Kelly was arrested and committed to an asylum when he refused to tell his name, occupation or address. After a year, he escaped and made his way home to Dubuque. The gold was gone. He never spoke of the trouble but never evidenced any guilt either.

In his final years, he lived with his sister, Elizabeth. He died on May 16, 1867, at 3:00 p.m. His funeral was attended by old settlers and friends. His grave is at Linwood Cemetery.

Thomas Kelly lived the life of a hermit. Although wealthy, he lived with little creature comfort. He joined in no public enterprises but allowed others

The oldest stone structure in Dubuque. *Author's collection.*

to enjoy the grove of oaks on his bluff and talked on many subjects with friends, while avoiding strangers.

The question of the final whereabouts of his gold was never answered. It was said that when asked about his gold, he replied, "If you want it, you will have to dig for it." Many have. Some believe he may have had the gold buried with him, while others believe it is still somewhere on the bluff. Two

boys once found an iron chest with $10,000 in $10 and $20 gold coins. They returned it to Elizabeth Kelly. People are still trying to find Kelly's gold on the bluff overlooking Dubuque. In 1861, $4,000 was found in the Kelly cabin, and even more was found in a tin can and an old tea canister. While his mines contained lead, no more gold was ever found. Rumors of ghosts and gold—as well as the search for Kelly's gold—continue.

Chapter 3

LEAD BROUGHT THEM

LOST AND FOUND

On the Mississippi River, beneath Eagle Point, in the city of Dubuque, the federal government built the General Zebulon Pike Lock and Dam #11 in order to maintain a channel nine feet deep to facilitate better barge shipping and boating. Construction began in 1933 with land acquisitions. The lock opened for business in 1937, with the dedication ceremony on August 8, 1938.

The Zebulon Pike Lock and Dam, the only one of the twenty-nine structures built in the Mississippi River to be named, spans 4,818 feet connecting Iowa and Wisconsin. Thousands of tourists and locals have watched the barges pass through the lock each year. Have they ever wondered who General Zebulon Pike was?

Born in Lamberton, New Jersey, in 1779, Pike was the son of an officer who was fighting in General George Washington's army during the American Revolution. It was natural that he followed in his father's footsteps with a career in the army. President Thomas Jefferson's desire to explore the unknown lands now owned by the United States after the Louisiana Purchase changed Pike's army career trajectory.

France had claimed the territory in 1682 as a result of explorations by Sieur de La Salle, who had named the region Louisiana in honor of King Louis XIV. France built few forts and sponsored no massive colonization effort but maintained a strong trading relationship with the Indians in the

region. When France suffered defeat at the hands of the British in the French and Indian War (1754–63), it ceded Louisiana to Spain, which had been its ally. In 1800, France, under the leadership of Napoleon Bonaparte, again acquired Louisiana with grand plans to create a world empire. Americans, weary of difficulties in trade with Spain through the port of New Orleans, now faced the prospect of a French empire controlling the port of exit for all the trade west of the Appalachian Mountains via the Ohio River. In the meantime, Napoleon sent an army to occupy his new territory. Thwarted in these desires by a slave revolt in Haiti, yellow fever, malaria and an impending war with Great Britain in Europe, Napoleon offered to sell Louisiana to the United States.

President Thomas Jefferson, despite constitutional concerns, rapidly approved the Louisiana Purchase in 1803. Its 828,000 square miles nearly doubled the size of the United States. The desire to establish trade relations with the Indians in the newly acquired territory, to finally ascertain the existence or lack of a Northwest Passage to the East and to increase scientific knowledge led President Jefferson to first send Meriwether Lewis and William Clarke on a voyage to the Pacific Ocean. That was not the only expedition fueled by economic interests and scientific inquiry.

In 1805, General James Wilkinson sent General Pike north on the Mississippi River to discover the source of the Mississippi, purchase sites from the American Indians for military posts and bring several Indian chiefs to St. Louis for negotiations, to evaluate the value of the Dubuque mines and to determine the extent of the British fur-trading interests on American territory. Despite the Treaty of Paris in 1783 ending the American Revolution and requiring the removal of British forces from American Territory, the British had not evacuated the rich fur-trading regions of the Upper Mississippi River. Not until the War of 1812 was that issue solved.

On August 9, 1805, Pike and a crew of twenty men—with no medical training, no interpreter and little scientific equipment—pushed off from St. Louis in a seventy-foot keelboat. Along the way, two of his men became lost. General Pike gave up hope of ever seeing them again. On September 1, 1805, they reached the Dubuque Mines. Pike was ill but met with Julien Dubuque, who provided a military-style salute from a cannon, a dinner and a meeting with several chiefs of the Sauk and Mesquakie.

General Pike came to the mines with a list of ten questions from General Wilkinson, but Dubuque skillfully avoided answering two of the questions and evaded the others. Dubuque had met Pike at the confluence of Catfish Creek and the Mississippi River. He stated that he had no horses, so the

six-mile trip to the mines was impossible; and, he consistently downplayed the amount of lead shipped from the mines. Probably fearful of taxes on his assets, he refused to allow Pike to inspect his farm fields, mines or buildings.

During the meetings, General Pike was amazed to see his two lost soldiers approaching camp. They had been found by James Aird, who was a business associate of Julien Dubuque. Nearly starved and naked, they were rescued, provided with food and clothing and brought to the mines by Maurice Blondeau, a trader and interpreter.

Neither General Pike nor Julien Dubuque recorded a meeting with a young Black Hawk at the mines, but it is presumed they did meet here. Black Hawk recorded meeting Pike and his men along the Rock River; therefore, it is believed they met twice. Black Hawk figured prominently in the history of the mines in 1832.

On September 2, General Pike and his men continued north and camped along the Turkey River. South of the confluence of the Wisconsin River with the Mississippi River on the Iowa side, there is a high point overlooking a truly fantastic view. This point has been named Pike's Peak in honor of General Pike. The more famous Pike's Peak in Colorado was the second such tribute for Pike. At Prairie du Chien, the expedition switched from the keelboat to barges for the reminder of the northward journey.

While north of the Falls of St. Anthony, the present site of St. Paul, Minnesota, they were engulfed by a Minnesota winter. Without the aid of the British traders they were sent to oppose, they would have starved. General Pike negotiated a purchase price of $200,000 for 155 acres to build a fort at the confluence of the Minnesota and Mississippi Rivers. Eventually, Fort Snelling was constructed here, but paying approximately $1,200 an acre for wilderness in 1808 was not approved by Congress. The Indians eventually received $2,000.

On April 23, 1806, Pike's expedition returned to the Dubuque Mines, where he found a few traders and fifty Indians but secured no more information before leaving the next day. On April 30, they reached St. Louis and the conclusion of their five-thousand-mile journey.

General Pike did not find the source of the Mississippi River, did not bring Native American leaders to St. Louis, did not discourage British traders (and, in fact, when the War of 1812 occurred, the Indians supported the British) and did not ascertain the value of the Dubuque lead mines. He did, however, provide a site for the future Fort Snelling and prepared himself for his next expedition to the Southwest, where he was captured by the Spanish after crossing into Mexican territory, imprisoned and later

returned to Louisiana. Several of his men were kept in prison for years, despite no state of war existing between the United States and Mexico.

Due to his association with General Wilkinson, General Pike very nearly had his career destroyed. General Wilkinson was not only the commanding general of the American army but also a secret agent of the Spanish government. He became the governor of Upper Louisiana Territory with the help of Aaron Burr, the vice president. Involved in Burr's plot to separate the western half of the United States, he later switched sides and testified against Burr, and the conspiracy failed. Vice President Burr was tried but acquitted of treason. President James Monroe fully exonerated General Zebulon Pike. During the War of 1812, Pike was killed by a British bomb while leading the successful Battle of York in Canada against British regulars, militia and Ojibwa natives.

In 1810, Pike had published a book about his explorations. It was so tremendously popular that it was translated into several languages. His adventures led to the naming of a dam on the very river he had explored a century and a half earlier.

A LOVE STORY ON THE FRONTIER

Love stories are always popular, and tragic love stories even more so. Lieutenant Jefferson Davis, a West Point graduate and future president of the Confederate States of America, and the love of his life, Sarah Knox Taylor, were once the topic of just such a story at the Dubuque Lead Mines.

In 1828, Lieutenant Jefferson Davis boarded a steamboat in his home state of Mississippi, bound for Jefferson Barracks at St. Louis, where he was assigned to Fort Crawford at Prairie du Chien. He helped to cut logs along Red Cedar River in northern Wisconsin and float them down the Chippewa River to the Mississippi River for their destination at Prairie du Chien to build the fortifications there for Fort Crawford. This was a very dangerous assignment given the hostilities of the Indians, the danger of cutting trees and the hazardous task of log rafting on rivers swollen by spring floods.

Meanwhile, in 1829, Lieutenant Colonel Zachary Taylor, along with his wife, son and three daughters, arrived in Prairie du Chien for his assignment commanding Fort Crawford. In 1831, Lieutenant Davis returned to Prairie du Chien and no doubt was charmed by Taylor's beautiful daughter Sarah. She returned the affection as the couple courted in the presence of her father. This idyllic scene soon changed.

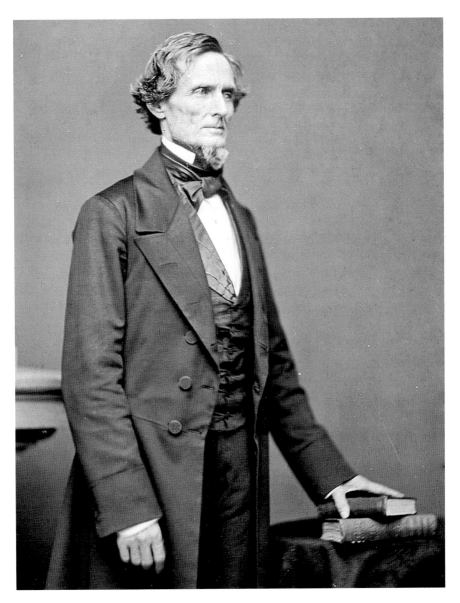

Jefferson Davis. *Courtesy of Matthew Brady.*

During a court-martial at Fort Crawford, Davis, Major Thomas Smith and another young officer served as the court with Taylor acting as president of the trial. The accused young officer appeared at the proceedings absent his uniform, which he claimed had been delayed in St. Louis. Taylor, a stickler

for regulations, berated him severely and refused to continue the court-martial. Finally, a vote was called, and Davis voted with Smith, overruling Taylor. An angry discussion resulted in Taylor swearing at Davis, prohibiting him to even enter the Taylor home and forbidding his marriage to Sarah.

To ensure Sarah and Davis were kept apart, he sent Lieutenant Davis south to the Dubuque lead mine region to expel the miners who were on Indian Territory illegally. No doubt, he thought the miners who believed the American government was denying them their rightful access to the rich lead veins would kill Davis.

Since the Dubuque lead mines were on the west bank of the Mississippi River, they were on Indian lands. The Mesquakie and Sauk had allowed no one to mine the lead there since Julien Dubuque's death. They had destroyed all the buildings and furiously protected the region. Galena and Mineral Point to the east had become the centers of the lead rush in the Driftless Region. These miners often crossed the river, mined illegally and escaped to the islands in the river when the military arrived.

Lieutenant Davis had a reputation as an excellent negotiator, so rather than attack the miners, he met with them in a drinking establishment at the Dubuque Mines. He persuaded them to leave, burned the cabins and returned to Fort Crawford. On one foray to the lead mines, he stopped at Sinsinawa, only a few miles east of the Dubuque mines, to visit his former classmate and friend George Wallace Jones. A chance meeting on the frontier reestablished a friendship that became an issue during the Civil War. Jones had built a fort at Sinsinawa and mined and farmed there. He later moved to Dubuque and became a U.S. senator.

Once the military had vacated the Dubuque mines, the miners returned. It was a familiar dance. Prospects for the permanent ownership of the mines by the Indians were dim.

Sarah and Davis vowed to marry despite her father's opposition. In June 1835, Lieutenant Jefferson Davis quit the military and followed Sarah to her aunt's plantation in Kentucky, where they wed on June 17, 1835. They returned to Davis's plantation of Brierfield in Mississippi.

Sadly, only three months after their marriage, Sarah died of fever. Davis was profoundly distraught. When he remarried years later, he insisted that he and his new wife visit Sarah's grave on their honeymoon.

LEAD FEVER

The lead that brought world attention to Dubuque brought Americans seeking their fortunes in the early nineteenth century. The Mississippi River provided easy access. The American government withheld ore-bearing lands from sale by developing a leasing system. This system proved unenforceable and eventually was terminated. Miners in the lead regions of Missouri were already mining under a Spanish patent when the Louisiana Purchase occurred in 1803. These miners who rapidly moved north were not enthusiastic about the leasing system. In addition to their issues with the government, miners were not allowed to farm on leased lands, so provisions were always in short supply.

The Fever River Mining District, centered in today's Galena, Illinois, became the center of the lead-mining activity. The Army Bureau of Ordinance advertised for prospective lessees requiring a $10,000 bond and a minimum of twenty workers for a lease on 320 acres. Stone and timber could be used by the lessee but no farming. The government required 10 percent of the finished product in payment. There was no rush to acquire leases.

Joseph Meeker heard of the lead from a trader in St. Louis who had been smelting ore from the Dubuque fields (illegally). He arrived on the Fever River in 1822 to find Colonel James Johnson of Kentucky operating near present-day Galena. Meeker accepted the lease arrangements. He set out from Cincinnati on the Ohio River in April 1823 with a crew of nineteen, two of whom brought their families, $7,000 in equipment and three dogs. After fifty-eight days, they reached the Fever River. Colonel Johnson decided the hazards were too great and the profits too small, so he left the area at the end of 1823. Meeker stayed.

In 1822, there were twenty non-Indians living in the lead district, but by 1828, there were ten thousand residing and working there. Enforcing the leases and prohibiting farming became impossible as squatters claimed land and waited for an official survey and sale. In 1825, the Erie Canal opened, making the upper Midwest even more accessible from the eastern United States and immigrants coming from Europe. The pressure to cross the Mississippi River for the rich ore lands at Dubuque increased.

Among the first to cross the Mississippi illegally were James Langworthy, Patrick Quigley and Thomas McCraney. Langworthy had been mining at Galena, Illinois, and Hardscrabble (now known as Hazel Green), Wisconsin, in the Mineral Point Mining District, but the lure of lead at

the old Dubuque mines proved too strong. In 1829, they secured from the Mesquakie, who continued to work the mines and trade, the right to explore the Mines of Spain area. There is no record of their conclusions, but in 1830, Langworthy and his brother Lucius returned to commence mining operations. Lucius hit a lead deposit near the present site of Kaufman Avenue. They continued mining illegally along with another brother, Edward, when the soldiers were not present and escaped to the islands or the east side of the river when the soldiers arrived.

On June 17, 1830, the group of fifty-one miners at the Dubuque Mines wrote and signed the Miners' Compact. It was most likely the first set of laws in Iowa. The Couler Valley and Union Park areas just north of Dubuque proved successful for them. Thomas McCraney had brought his wife, who was due to give birth. They constructed a cabin, but the soldiers drove them out. Having nowhere else to live that winter, they snuck back across the river and took up residence in a cabin that had been missed by the soldiers. There, on January 10, 1830, Susan Ann McCraney was born. She was the first non-Indian child born in Dubuque and probably in Iowa. By the time legal residency was possible, the Langworthy brothers, Thomas McCraney and his family and the others had already surveyed the best sites for lead, development and farming.

BLACK HAWK, LEAD LUST
AND LAW AND ORDER

The lust for lead on the west bank of the Mississippi River caused miners to continually push against the American government's policy of protecting the Indian Territory. Despite the army's attempt to remove illegal miners, a leasing system to prohibit farming in mining regions and no government infrastructure in the vicinity, miners sought out the riches. They believed they were doing the government's job of settlement and forced a change in policies.

In 1825, the American government held treaty negotiations at Prairie du Chien, Wisconsin. It was an attempt to cease war among the various groups of Indians in the region. A neutral ground established in northeast Iowa failed to end the hostilities. Meanwhile, the Indians became increasingly dependent on the traders for the sale of their lead and the purchase of the manufactured goods that had permanently altered their lifestyle. These traders occupied the river islands to avoid the army.

George Wallace Jones, a friend of Jefferson Davis, lived at Sinsinawa in Wisconsin after moving from Missouri with his slaves in violation of the Northwest Ordinance of 1787 that had declared slavery illegal north of the Ohio River. In 1828, the Mesquakie required Jones to trade with them. From the death of Julien Dubuque in 1810 to the Black Hawk War in 1832, commerce between the Indians and Americans continued through the agency of these traders.

In 1823, the *Virginia*, the first steamboat to make its way up the Mississippi River, arrived at the Dubuque Mines. Henry Schoolcraft, an Indian agent,

and Thomas McKenny, the superintendent of Indian Affairs, found the mines to be in a state of disrepair. The Mesquakie steadfastly denied all attempts by the government to buy their land.

After a group of Mesquakie on their way to Prairie du Chien for treaty negotiations in 1829 were ambushed by Menominee and Sioux, these two tribes again went to war in 1830 with the Mesquakie. The miners quickly took advantage of their absence. James Langworthy and other future founders of the city of Dubuque arrived during this period. Lieutenant Jefferson Davis, sent from Prairie du Chien to expel the miners, commented that the miners were still in the region. He noted that there was a smelting furnace on the Platte River to service the lead from the area north of the Dubuque Mines and that lead was being routinely shipped down the Little Maquoketa River. Lieutenant George Wilson, brother of Judge Wilson, one of the illegal occupants of the mines, declined to remove the miners and was replaced by Lieutenant Covington, who seriously fulfilled his duties. He was hated by the miners, who fled to the islands with their ore and waited.

Saukenuk, the largest Sauk settlement and Black Hawk's (Sparrow Hawk or Ma-ka-tai-me-she-kia-kiak) birthplace, was located at the junction of the Rock and Mississippi Rivers. In 1804, Henry Harrison, governor of Indiana Territory, negotiated with southern Indians to give up their land east of the Mississippi River, including Saukenuk. The northern Indians never recognized this cession and refused to leave. Black Hawk resisted all settlement by Americans. He fought with the British in the War of 1812 as their ally, but when the British were defeated and finally left the Northwest Territory, they made no provisions for their Indian allies. Despite this betrayal, Black Hawk continued to travel to the British fort near Detroit for trade and clung to the hope that the British would come to the assistance of his people if needed. When Illinois became a state in 1818, tensions with the Sauk increased to the breaking point.

Black Hawk, a war leader who gathered like-minded people around him, disagreed with Chief Keokauk of the Sauk. Chief Keokauk agreed to move the Sauk permanently west across the river, but Black Hawk refused. After a hunt west of the river, Black Hawk and his people—known as the British Band—returned to Saukenuk in the spring of 1832. Panic and rumor flooded across the frontier. Militias were called to action along with the regular army. Black Hawk decided to surrender and ask permission to cross the Mississippi River.

Despite carrying a white flag, his emissaries were attacked by undisciplined militia under the command of Isaiah Stillman on May 14, 1832. The Indians

returned fire, and the militia fled in panic. Unable to surrender, Black Hawk led his band up the Rock River, striking outlying settlements and evading the military. The Ho Chunk (Winnebago), Kickapoo and Pottawatomie did not come to his aid. The British refused any assistance as well.

With the soldiers in pursuit, Black Hawk led his people throughout northern Illinois and southern Wisconsin. In an attempt to save those who were unable to keep up, he sent them down the Wisconsin River so they could cross to the west side of the Mississippi River, but they were cut off by the Menominee and militia. Only a dozen survived.

Forty miles north of the Wisconsin River, near a small stream known as the Bad Axe River, Black Hawk and his remaining band came to the Mississippi River with the army in close pursuit. The armed steamship *Warrior*, with soldiers on board, cut off their retreat. The massacre was nearly complete. Those not shot on the shore were killed attempting to cross the river or drowned. Those who did make it to the west bank of the river were attacked by the Dakota. Only 150 of the original 2,000 returned to Chief Keokauk's band. Black Hawk escaped to northern Wisconsin, where he was captured by the Ho Chunk and returned to the Americans.

After being imprisoned briefly, Black Hawk was taken to Washington, D.C. He was then given a tour of the Atlantic seaboard. The point of this exercise was to impress on him and others the futility of resisting the spread of the Americans.

In his autobiography, Black Hawk wrote, "The Rock River was a beautiful country. I loved my towns, my cornfield, and the home of my people. I fought for it. It is now yours. Keep it as we did."

The Black Hawk Purchase was a land acquisition made in what is now Iowa by the United States government. The land, originally owned by the Sauk, Mesquakie (Fox) and Ho-Chuck (Winnebago) was acquired by treaty following the Black Hawk War. The purchase was made for $640,000 on September 21, 1832. The region is bounded on the east by the Mississippi River and includes Dubuque. Chief Keokauk answered a complaint of the Ioway Indians that the Mesquakie and Sauk had no right to cede the territory west of the Mississippi River by stating, "This country I have gained by fighting. Therefore, I claim it." Reservations in Kansas and Oklahoma became the new homes for the Mesquakie and the Sauk, but some Mesquakie never left while others returned repeatedly.

The genie was out of the bottle. The Dubuque mines were now available, but not just the mines. Valuable farmland soon became a tempting resource as well.

When the miners arrived to legally settle Dubuque in June 1833, they found a grocery that had been stocked with goods from Galena by Noble F. Dean in the fall of 1832. Mr. Dean had erected a hut to commence commerce near the Langworthy smelting furnace on Mineral Street. A saloon operated by Sam Morris existed as well. The 1833 arrivals joined J.L. Langworthy, Thomas McCraney, Patrick Quigley, J. Parker, I.E. Wooten, Lucius Langworthy, O. Smith, Thomas Kelly, W. Thompson, Edward Langworthy, William Carver, Leroy Jackson, J. O'Regan, Woodbury Massey, John Cunningham, J. McKenzie, Robert Waller and others who, along with their families, already occupied some of the best locations.

John Sheldon, superintendent of mines, granted permits to the miners and licenses to the smelters. New arrivals included W.G. Stewart; P.A. Lorimier; J.P. Farley; Matthias Ham; Solon Langworthy; John Floyd; A. Levy; Dr. Allen Hill; Mrs. Martha Harrison, a cousin of Davy Crockett; and many others from the eastern states, as well as European immigrants. They worked the mines, built homes and planted their fields in a landscape very different from the present day. The hillsides were not covered with trees, as it was a custom of the Indians to burn off the undergrowth to encourage the presence of grazing animals. The Mississippi River, filled with islands, meandered between the bluffs. Wetlands proliferated along the river, and the Little Maquoketa River to the north flowed deeply and swiftly to support mills, kilns and barges.

The summer of 1833 introduced a new enemy to the settlers: cholera. A bacterial disease found in contaminated water or food, cholera attacks rapidly and fiercely. If a person consumes food prepared in contaminated water or undercooked or raw fish from contaminated water or drinks that water, a toxin released in the small intestine triggers severe diarrhea and vomiting. Dehydration, rapid heart rate, muscle cramps, a blue/gray skin color and low blood pressure follow. Death resulted for many. A man named Fox was the first to die. He was buried somewhere on South Avenue. James Frith fell next. He was at work in his blacksmith shop on the corner of Bluff and Fourteenth Streets when cholera struck. After a few hours, he died and was buried in the new graveyard in what is now Jackson Park. Mrs. Cullom and her infant soon joined the others in the new cemetery. The town and its operations came to a standstill while Dr. Allen Hill and Dr. John Stoddard ministered to the ill and others buried the dead. At least fifty people died of cholera that summer. Apprehension filled the survivors as they faced winter in the new settlement.

No epidemic arrived with winter, but one man's illness during this time demonstrated the charity and compassion of the miners, as well as a keen sense of justice. After arriving from Missouri, Mr. Davis fell seriously ill. The miners collected funds to help him, but it appeared that his death loomed in the not-too-distant future. They gathered $175 to hire two men, Mr. Wheeler and Mr. Stoner, plus a sleigh and supplies, to return Mr. Davis to his home. Wheeler and Stoner successfully delivered him to his father but not before unscrupulously taking more donations to fill their own pockets along the route. When news of their behavior reached Dubuque, the miners were enraged. They formed a committee with William Smith as its chair to decide what action should be taken. When Wheeler returned to the mines, he was captured at McGary's Landing, a tavern located at the present corner of Jones and Main Streets. Marched up Main Street as a crowd gathered, he attempted but failed to escape. After removing his coat and shirt, the mob covered him in tar, to which Frank Massey added feathers taken from his brother's house. Mr. Wheeler was then escorted across the river. His partner had the good sense to not return to Dubuque with his profits.

Since Dubuque was officially part of the Wisconsin Territory and the closest justice system was almost 250 miles away in Green Bay, law and order on this mining frontier of necessity had to be a local affair. The case of Patrick O'Connor demonstrated this point clearly. O'Connor, born in Ireland in 1797, came to Galena, Illinois, to mine lead in 1826. Two years later, he suffered a broken leg. The leg had to be amputated. His fellow miners willingly paid for his medical and living expenses. O'Connor's behavior soon lost him both the charity and support of the community. He burned down his cabin in an effort to secure more funds and nearly destroyed surrounding property. When a Galena merchant, Mr. Brophy, exposed him, O'Connor burst into his store and fired off his gun in an attempt to kill Brophy. Now facing the charge of attempted murder, O'Connor left Galena for Dubuque.

In Dubuque, he partnered with George O'Keaf. They built a cabin south of Dubuque and began a mining operation. On May 9, 1834, Mr. O'Keaf and a friend returned to the cabin with provisions only to find the door locked. O'Connor refused to open the door, so O'Keaf forced it open only to be shot and killed by O'Connor. The friend escaped by running to the smelting furnace of Wilson and Hulett. An assembly of miners returned to the cabin, where O'Connor waited. His only reply to the question of why he shot his partner was that it was his business.

The first thought was to hang him immediately, but cooler heads prevailed, and he was taken to Dubuque, where on May 29, 1834, the first

trial for murder in Dubuque was held under a large elm tree. Captain White was appointed the prosecuting attorney, and Captain Bates from Galena was the defense attorney. Members of the jury included Woodbury Massey, Hosea T. Camp, James McKenzie, Milo Prentice, Jesse Harrison, Thomas McCraney, Antoine Loire and Nicholas Carroll. O'Connor believed that since no law existed in the territory, they had no right to put him on trial. Captain Bates wanted O'Connor sent to Galena, where he could be tried by a legal court, but since others who had been sent there had been freed due to Illinois having no jurisdiction at the Dubuque mines, it was decided to continue the trial at the present location. Witnesses were heard, and after an hour of deliberations, a guilty verdict with a death sentence by hanging was announced. Applications to the governor of Missouri and the president of the United States to pardon him were denied, as they replied that they had no jurisdiction.

Rumors that miners from Mineral Point, Wisconsin, were coming to rescue O'Connor roused the miners to action. Under the command of Loring Wheeler as their elected captain, 163 men lined Main Street. They then elected W.I. Madden, Woodbury Massey, Thomas Brasher, John Smith and Milo Prentice as "Marshalls of the Day." Marching to the accompaniment of a fife playing the death march as spectators gathered, stores closed and passengers from two steamboats from Galena and Prairie du Chien disembarked to witness the hanging, they arrived at the house of Herman Chadwick, where O'Connor was held. O'Connor rode on his own casket in a wagon to the gallows at the present site of the courthouse. No one arrived to rescue him. He was hanged at noon after admitting he murdered O'Keaf and begging forgiveness. The first capital punishment in what became the state of Iowa was now history.

Meanwhile, north of Dubuque at the intersection of the north and south branches of the Little Maquoketa River, John Ewing, who had lead mines in the area, returned to his smelting furnace to discover that one of his employees had slapped Ewing's child for disobedience. Ewing traveled to his mines, found the employee and shot him. Despite several witnesses, no one testified against Ewing at his trial. After his acquittal, he decided to leave the county.

A sensational event occurred in 1835 that involved several prominent community members. Woodbury Massey, his brothers and sister were among the first of Dubuque's settlers. They were founders of the Methodist church erected in the city, as well as involved in many other community endeavors. Mr. Massey had purchased a lot and mineral lode with a disputed claim.

The Smiths, William and son, held that they, not Massey, owned both the land and mineral. A lawsuit decided against the Smiths, but they were not to be deterred. Hiding on the claim, they shot Massey through the heart when he arrived. The Smiths were apprehended, charged with murder and held until the session of the Circuit Court at Mineral Point, Wisconsin. The defense objected as the jurisdiction of the Circuit Court was questionable. After release, the defendants vacated the region temporarily.

The younger brother of Massey promised to kill the assassins if he ever saw them. The opportunity came soon. Henry Massey observed the elder Smith strolling the streets of Galena, quickly fetched his pistol and killed him. He was never arrested or tried. In fact, citizens viewed the death as necessary.

The younger Smith, however, did not agree with this opinion. Upon returning to the mines, he vowed to kill one or both of the remaining Massey brothers. Louisa Massey, age sixteen, feared for her brothers. She disguised herself and sought out Smith. She found him on Main Street, demanded that he defend himself, then shot him in the chest. Louisa fled to a friendly house, then to her brother's and, in the morning, to Galena. Smith was very lucky that day. In his chest pocket, he had carried a wallet filled with papers. These papers slowed the bullet, so he survived. His determination to seek out and kill Louisa Massey failed since he died later from the wound.

The townspeople, outraged over the ongoing violence, called a miners' meeting to address the jurisdiction problems. They threatened to use the services of "Judge Lynch" if the criminals did not leave the city within thirty hours. Many took the advice and fled.

Louisa's return to Dubuque was greeted with such enthusiasm that the boat carrying her almost sank as supporters attempted to meet her. She later married Mr. S.J. Williamson. Louisa County in southeast Iowa was named to honor her role in the founding of the state. It is one of only two counties in Iowa with female names, the second being Pocahontas in north central Iowa.

In 1834, the governor of the Michigan Territory appointed Lucius Langworthy the first sheriff of Dubuque. Peter Lorimer became the first person with judicial authority when the governor of Michigan Territory granted that also in 1834. The first court to be held in Iowa Territory convened in Prairie la Porte, now Guttenberg, in September 1838. Law and order had come to the mining frontier.

Chapter 5

THE LITTLE MAQUOKETA RIVER

Julien Dubuque's claim covered approximately the area from Catfish Creek to the Little Maquoketa River along the Mississippi River. Julien Dubuque referred to the Masqanquitois River, where he placed a marker at its confluence with the Mississippi in order to keep other miners away from his claim. The Little Maquoketa River drains one third of Dubuque County. Originally a clear, rapidly flowing stream with a gravel bed, it provided the power for sawmills and gristmills along its banks, and it even allowed small lead barges to reach as far as the confluence of its north and south branches. Today, it is silted and sluggish unless fueled by floods, which can cause its width to increase from twenty feet to six hundred feet to fill the entire valley.

Lead miners actively sought their fortunes throughout the region surrounding the city of Dubuque. The Little Maquoketa River Valley drew them with promises of riches. One settlement competed with Dubuque for status, but the better harbor location allowed Dubuque to grow and prosper instead of its competition.

Located near the mouth of the Little Maquoketa River at the present site of the John Deere Dubuque Works factory, Peru once courted the leadership position in the new mining frontier. Peru Township is the oldest of the Dubuque County townships. Thomas McKnight, Francis Gehon, Thomas Carroll, Michael Powers, Brayton Bushee and Augustus Gregoire founded Peru, but miners had occupied the site much earlier. The army had been evicting these illegal residents of Indian Territory only to see them return. Lieutenant Davis had commented on the barges of lead being transported

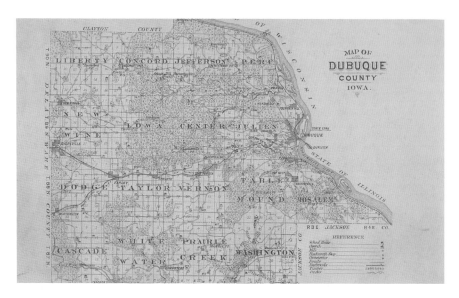

This 1880 Map of Dubuque County, Iowa, includes the village of Peru. From *1880 History of Dubuque*.

down the Little Maquoketa River to the Mississippi River on his excursions to the mines to expel miners.

On July 2, 1836, an act of Congress created a Post Road from Dubuque to Peru and then on to Durango. In December 1836, a post office—only one of three in Iowa—was established in Peru. It closed in 1843. Francis Gehon operated a store, Thomas McKnight built a smelting furnace, and many homes existed in the village. In June 1836, a temperance lecture in Peru illustrated a cultural shift arriving on the frontier. A racetrack and McKnight Springs for picnics provided entertainment. In 1858, the horse Iowa John defeated both Spot and Roan in a mile race for a $25 purse. A $200 purse provided suspense for the race between Fox and Wild Bill in a half-mile race. Violence was not absent from Peru, as evidenced by the fact that William Dailey killed J. Leyden at the racetrack in August 1858.

Peru and Bellevue, south of Dubuque, had comparable populations in 1836, but Dubuque eclipsed both settlements. By January 23, 1872, the *Daily Times* had listed Peru merely as a railroad siding along the former Chicago, Milwaukee and St. Paul Railroad. Farms filled the area, many of them small garden farms supplying produce to Dubuque's thriving farmers' market. Noting the necessity of expanding its manufacturing facilities, John Deere Company announced on December 31, 1944, its intent to build a factory in or near Dubuque. By February 1945, Peru was selected as the preferred site.

Deere purchased 742 acres of the Peru Bottoms. Once construction began, all remnants of the once-thriving community disappeared. In March 1947, the Model "M" rolled off the assembly line and a new history began.

Chester Sage and Brayton Bushee moved inland from Peru along the Little Maquoketa River to build the region's first sawmill in 1834. They later added millstones made of buhr or hard rock to grind corn. Mr. Thompson arrived in Dubuque in 1841. He continued on to Sageville where he built a mill in 1852 to grind grain. Thompson's Flouring Mill, constructed of stone, had the capacity of 125 bushels a day. After his death, Mrs. Thompson retained majority ownership, but the property eventually was sold to Joseph Rhomberg. A fire destroyed the Rhomberg Flour Mill on January 7, 1943. At the time of his death, Joseph Rhomberg had purchased hundreds of acres near Sageville with the plan to create a recreation area by damming the Little Maquoketa River. Lakeview, as he named the site, was to include a hotel, cottages, boats and even toboggan slides for winter use. Nothing came of this development.

Following the Little Maquoketa River upstream, settlers founded the village of Timber Diggings. Located in Jefferson Township as a mining settlement, the Ralph Mollart Mine was the largest in the region. Long sealed by dynamite, the mine ran south to north and opened south of the platted site of the Timber Diggings or Durango. A government survey in 1836 listed David Hogan, George Beedle, J. Farrington, J. Abanatha and Edward Kenion as a few of the earliest miners to live in the area. The original site of Durango is presently the Datisman Farm along Highway 52 North. John Ewing, Thomas McCraney, Preseley Samuels and Nehemiah Dudley founded the town in the early 1830s. The official survey of 1837 does not record Durango, but foundations of this early settlement mark its existence.

Truly a boom-to-bust village, Durango depended on the lead. Calvin Roberts worked a claim without luck, so he sold it to Solon and Edward Langworthy for $1,000. In 1835, they struck a rich vein of lead. Durango boomed. Thirty to forty houses, two stores and five groceries dotted the hillsides. As with many boomtowns, violence often followed.

"Kaintuck" Anderson arrived in Durango from another lead town—Mineral Point, Wisconsin—in 1834. Anderson was described in the 1880 *History of Dubuque County* as "universally disliked…a hard-loafing, hard-drinking, hard-swearing, through-paced braggart, always ready to resort to the code and invariably silenced by any manifestations of determination on the part of an opponent." While visiting in Dubuque, Thomas McCraney

Timber Diggings charcoal pit. *Courtesy of Datisman Photo Collection.*

"ingloriously vanquished" him after Anderson threatened to kill McCraney during a disagreement. At the Timber Diggings, Constable Mayfield arrested Anderson, but tables were turned when Anderson grabbed a rifle and forced Mayfield to dance, climb trees and do other embarrassing activities. Anderson's luck was about to run dry.

Adam and Isaac Sherrill had diggings in sections 13 and 14 in Jefferson Township to the north of the Timber Diggings. Today, the town of Sherrill bears their name. Anderson quarreled with the brothers and threatened to kill Adam Sherrill on sight. Someone immediately informed Adam Sherrill of the threat. When Sherrill saw Anderson in Durango, he shot him dead. Sherrill was arrested for murder, tried and acquitted in the court of Justice Joseph T. Fales. Anderson's brother swore to avenge Kaintuck's death but never arrived in Dubuque or Durango, because he was arrested for horse stealing in Indiana and disappeared from history.

Located along the Paradise Valley Road, Mollart Mine was one of the most profitable mines in the region. Ralph and Mary Ann Mollart from Staffordshire, England, sailed to New Orleans and proceeded north on the Mississippi River to settle in Durango. Mrs. Mollart died in Durango at the

age of forty-six. Mr. Mollart moved to Dubuque in 1864. His son George remained in Durango until 1868, when he also moved to Dubuque. He continued in the mining profession for two more years, at which point he bought a farm. In later years, ocher from the hillside was mined to add a red pigment to linseed oil for the red paint used by many local farmers. By 1845, the lead was gone. The bust of the boom or bust had arrived.

The miners left Durango, but others stayed to farm. Preseley Samuels served as the first postmaster in 1837. It was a short-lived post office, as it opened in March and closed in November. In 1850, Samuels again worked as postmaster for the reopened post office in Section 36 of Jefferson Township. A school built in Section 34 served the local children. The Old Rock Congregational Church in Section 35 of Jefferson Township no longer exists, but the cemetery remains. Gravestones such as those of Mathias Spurgeon and Ralph Mollart span the years 1846 to 1870. The Reverend J. Francis Fawkes ministered to the settlers from 1867 to 1869 and again from 1878 to 1889.

A famous visitor once occupied a home in Timber Diggings or Durango. Zerelda James married Dr. Reuben Samuels, her third husband. Her brother-in-law, Preseley Samuels, whose home served as the Durango post office in 1837, offered Jesse James and his gang a resting place in 1876. The infamous picture of the James gang owned by the Jesse James Bank Museum in Liberty, Missouri, shows them posed outside a log cabin previously believed to have been in Durango. Unfortunately, this picture had been misidentified and the people in it are not the James gang. The picture has been published in many books despite that fact and has been since removed from the museum. The home of Mr. and Mrs. Gary Childers, once believed to have been the home in the picture, was owned by Preseley Samuels and did offer shelter to Jesse James and his cohorts.

Local lore holds many Jesse James stories. Several miles from Durango, a home known as the Jim House was said to have housed mysterious occupants who came and went quietly. One man who always rode a large black horse was believed to have been Jesse James. Named for the James gang, the home no longer exists but the stories linger.

The railroad brought either prosperity or death to towns, according to its location. When the citizens of Durango heard rumors of a coming railroad, they relocated the town less than a mile farther along the Little Maquoketa River to Section 31 of Peru Township to take advantage of the railroad in 1881. The Chicago, St. Paul and Kansas City Railroad began at Eleventh and Pine Streets in Dubuque on November 10, 1885. Within a year, it had

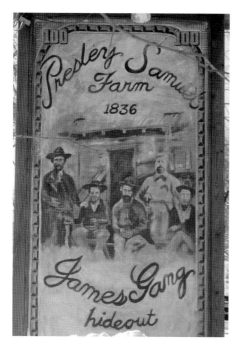

Presley Samuel Farm sign. *Author's collection.*

reached Farley, Iowa, to the west. In 1887, the Minnesota and Northwestern Railroad acquired the Chicago, St. Paul and Kansas City. It leased the tracks to the Chicago Great Western Railway Company in 1892. The Durango depot built in 1892 allowed riders to quickly and efficiently travel to and from Dubuque and beyond. A siding made it possible for farmers to load stock for market. Durango enjoyed a brief revival due to the railroad.

A catastrophic flood of the Little Maquoketa River in 1896 swept away the depot and killed five people. Mrs. James Clarke had been in charge of the station at Durango. She and her six children, along with visitors Steven Schmidt and Mary Lindecker, waded through the water to the depot, as it seemed a safer location than their home close to the river. Along with the Clarkes, the depot was occupied by the Drawl family; Tom Griffin, a brakeman; and John Birse, a foreman of the wrecking crew working on a wreck that had occurred the night before. During the night, the water encircled the depot. The frightened occupants watched as the water rose into their presumed safe haven. At 2:10 a.m., a rush of water and debris overtook the depot. Mr. Griffon, three of the Clarke children and a child held by Mr. Griffon drowned. James Dillion and P. Moss stepped onto the platform of the depot to check on the water level during the storm and were swept away with the platform. They reached out in the darkness for branches. Luckily they found a tree and climbed to its upper reaches. The Clarke family lost four children that night. The bodies of Mr. Griffin; Mary, age nine; Margaret, a baby; and three-year-old twins were all eventually recovered for burial.

A two-story depot replaced the original depot. The second story served as a residence. In 1948, the depot closed. The Chicago and North Western Railroad bought the Chicago Great Western Railway Company in 1968. In 1978, the railroad became the Chicago and Northwestern Transportation

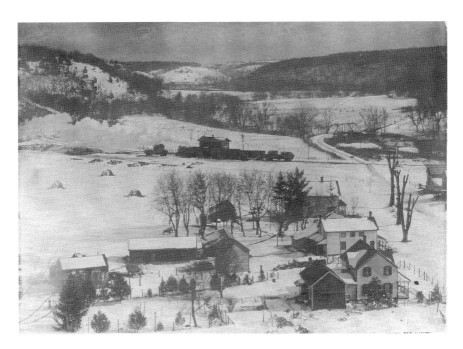

Durango from the air in the winter of 1913 or 1914. *Courtesy of Datisman Photo Collection.*

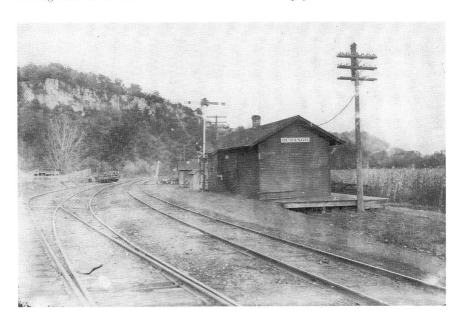

Original Durango Depot. *Courtesy of Datisman Photo Collection.*

Company. The tracks fell into disrepair and finally ceased to exist on March 31, 1981. The Heritage Bike Trail, owned by the Dubuque County Conservation Board, now occupies the old rail bed from Dubuque to Dyersville, Iowa.

Lattnerville, located in Section 30 of Center Township, bustled with activity in the nineteenth century. Today, little evidence of its existence remains. Previously named Channingsville, this hamlet rested on the banks of the Little Maquoketa River. A French Canadian settlement at first, it had evolved into a town boasting a sawmill, woolen mill, furniture shop, blacksmith shop, two stores and other businesses by 1874. After a devastating fire, the town was rebuilt and named for the Lattner family, who owned much of the surrounding farmland.

Paul Lattner operated a store and is credited with introducing the production of honey into the area with his two hundred hives. His son Samuel B. Lattner, who was born at Lattnerville in 1862, became a prominent Dubuque attorney. Bob McCants delivered the mail that arrived twice a week by stage. Mr. Carmel served as a postmaster. Gideon Lorimer, nephew of Peter Lorimer in Dubuque, owned the second store. His wife, who was an Indian, used her knowledge of herbs to make

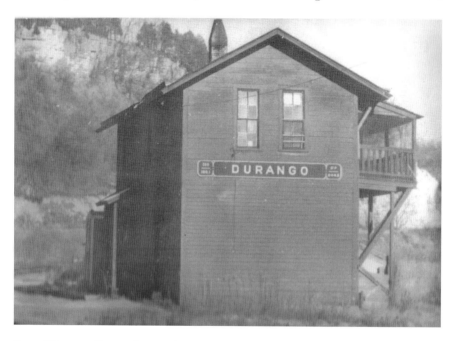

Second Durango Depot. *Courtesy of Datisman Photo Collection.*

Durango School, 1926. *Courtesy of Datisman Photo Collection.*

Durango Cane Mill in 1905 or 1906. *Courtesy of Datisman Photo Collection.*

medicine for the settlers. Their two daughters continued the practice of assisting the new settlers.

Felix Florida and his family built the first frame home in Lattnerville. His Twelve Mile House provided shelter for weary travelers. Their reputation was less than savory. According to an article in the *Telegraph Herald* on August 23, 1931, travelers unaware of this reputation often lost their valuables while they slept. One incident involved a young man who commented that the Florida family slept by day and stole by night. Unfortunately for him, one of the Florida boys overheard his comment and hit the traveler so hard that he carried the reminder to his grave.

Dan Bruner and Dan Hill owned Bruner's Mill, which supplied both corn meal and ground wheat to its customers. Osborne's Grist Mill and Bowie's Saw Mill also used the Little Maquoketa to power their industries. Spark's Lumber Mill—an unfortunate name given the many fires suffered in Lattnerville—was taken over by Thomas E. Bradley after the Spark family headed west for less settled territory. Mr. Bradley produced excellent high-back split-bottomed chairs and trundle beds at his furniture factory. The Holly-Hood Woolen Mill used wool from the region's sheep to produce quality woolens. Today, the former

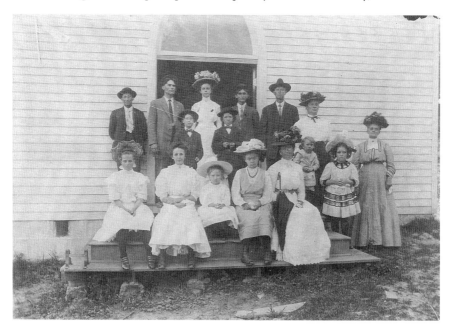

Durango church members. *Courtesy of Datisman Photo Collection.*

Annunciation Catholic Church occupies the site of the woolen mill. Another gristmill downstream from Lattnerville was operated by James and Alexander Sims, who had been engaged in milling in Rockdale and Sageville. They built the mill in 1868 after returning from the gold fields of California.

The Annunciation Catholic Church, earlier known as Marian Kirche, was established in 1868. Reverend J.B. Cowan set the cornerstone in place. Prior to the construction of a building, Catholics held Mass at the home of Mrs. Myers when her son, who was a priest, was available. Joseph Hafel married Annie Marie Hatter at the home of Mrs. Myers. The entire neighborhood celebrated with doughnuts, coffee and beer. There may have been a small stone church located at Channingsville, but no proof of that exists. The first person buried in the Annunciation Church cemetery, Barberry Oberfill, drowned after falling into the Little Maquoketa.

In 1867, unable to decide on a suitable compromise location for the Catholic church, the residents of Centralia and Lattnerville parted company. With the help of Father Meis of Dubuque, the Catholics of Centralia established a church for themselves. Five acres of land were secured from Andy McBreen for the church and two acres from the Lattner brothers for a cemetery.

Father Frauenhoffer of Sherrill's Mound attended a mission at Lattnerville for one year. Father Oberbroekling of Luxemburg, Iowa, came in 1872, riding seventeen miles on horseback to service the parish. One Christmas morning, he arrived for the 5:00 a.m. Mass only to return the seventeen miles to Luxemburg to conduct two more Masses. In 1874, he brought a French missionary, Father Isle, who conducted services and erected the mission cross at the church. He also began a choir under the direction of Mr. John Court. Without the benefit of an organ, they conducted the High Mass. Father Heimbrucher arrived in 1874. He was Lattnerville's only resident priest, but due to poor health, he remained there only ten months. Father Heer of Centralia arrived in September 1873. He held Mass at Lattnerville for the next five years. Father Nacke replaced him in 1880, followed by Father Joseph Kuemper, formerly a professor at St. Joseph's College in Dubuque, in 1883.

The church closed in 1884 on the order of Pope Leo XIII. It remained closed for two and half years until Bishop Hennessey granted permission to have an early Mass celebrated at the Lattnerville church each month, a practice that continued for ten years. Reverend P.A.R. Tierney served the parish beginning in 1898. He oversaw many improvements, as well as

delivering the homily in English and German, a practice that endeared him to his congregation. After lightning struck the church, it was again closed, causing the members to travel to Centralia to worship.

On September 2, 1922, Annunciation Catholic Church reopened with Father John J. Breitbach presiding. Tragedy again struck on March 30, 1945, when only an hour after a Mass celebrating the remodeling of the church, a fire gutted the structure. Undeterred, the residents rebuilt the church, replaced the dangerous oil lamps with electric lights and continued services. They even added a cement platform for a tent to facilitate picnics. By 1985, the parish consisted of thirty families served by Reverend Hemann of Loras College. In 2010, Annunciation Mission Church became an oratory, or a place of prayer. On June 8, 2013, an auction dispersed all the furnishings and real estate of Annunciation Catholic Church except for the cemetery. Dr. John Wahlen purchased the building and is at present restoring the structure.

Another boom or bust town, Lattnerville's fate was sealed by the coming of the railroad, or rather the failure of the railroad to come. During the

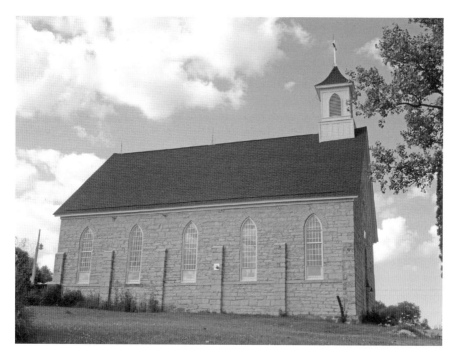

Lattnerville Annunciation Catholic Church. *Author's collection.*

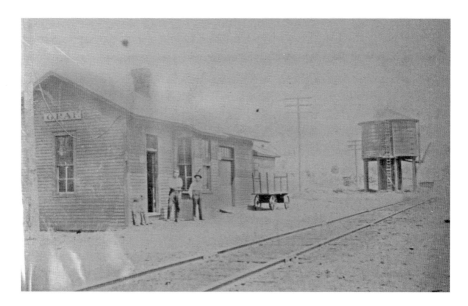

Graf Railroad Depot 1905 postcard. *Author's collection.*

winter of 1886, six hundred men labored on the tracks between Farley and Lattnerville. Unable to buy the necessary land for its tracks near Lattnerville, the railroad purchased land a few miles to the east. Lattnerville was doomed. A new town, Graf, began to spring up around the railroad depot. The wagon road from Centralia to Lattnerville was even abandoned. In 1931, the store and residence of J.L. Breitbach burned to the ground. With that fire, Lattnerville disappeared except for the cemetery and the church building that still stand in tribute to those early settlers.

Totally dependent on the railroad, Graf grew to include stockyards, a depot, a water tower, homes, a tavern, a store and a school. The train brought supplies ordered by area farmers and carried away livestock and lumber. After the railroad depot closed in 1950, Graf gradually declined. The post office closed its doors in 1955. As with Durango, where the Chicago Great Western no longer maintained the tracks, by the early 1970s Graf's fate was sealed. After the tracks were removed and the Heritage Bike Trail replaced the trains, tourists often stopped in Graf for pie and other refreshments, but eventually the store closed too. Graf remains a community with a sawmill and a tavern, but the raucous days of a railroad boom are a distant memory.

The name *Maquoketa* means "there are bears." In 2015, a rider on Heritage Trail along the Little Maquoketa River saw a bear run across the trail—back to the future, perhaps?

PARKS, PICNICS AND TRAGEDY

D ubuque County has always possessed a multitude of entertainment venues. Some are well known, while others have disappeared into the mists of history.

Among those that many people recognize even though they may not be familiar with the history, Union Park was located at the present site of the YMCA Youth Camp and Sky Tours Zip Line. Its history began with the marriage of William Stewart and Sarah Graham in 1812 and the birth of the eldest of their eight children, William Graham Stewart, in 1813. In 1833, William Graham Stewart arrived in Galena to mine the lead that lured so many to the Driftless Region. With the opening of the territory west of the Mississippi River after the Black Hawk Purchase, Stewart moved across the river. He determined that farming offered a more permanent source of prosperity, so he saved his money and eventually bought nine hundred acres of Iowa farmland. In 1842, he married Caroline Wilson. Involved in banking, railroads and the harbor, Mr. Stewart also served as sheriff, county treasurer, state senator and county supervisor.

Of their six children, William Jr., Mary and Helen continued farming after the death of their parents. The family home was located at the present corner of the Northwest Arterial and John F. Kennedy Road, formerly known as Union Park Road. In 1890, William donated several acres of the farm to create a "family outing place," as he called it. He believed families should have the opportunity to escape the city to enjoy nature.

In the spring of 1891, Dubuque Electric Railway Light and Power Company purchased forty acres of the Stewart farm with the option to purchase two hundred more acres for a potential resort called Stewart's Grove. The company extended a single trolley track out Couler Valley, today's Central Avenue and Highway 52, to the site. The trolley track crossed a stream known as the B Branch with eleven bridges. The trolley was the only way in or out of the renamed Stewart Park. Located in a horseshoe-shaped valley seventy-five feet deep, the park celebrated its grand opening on April 26, 1891. Described as a romantic and delightful spot, many buildings were planned.

Without the necessary money to maintain the park, the owners sold the company to the Old Colony Trust Company in 1893. For several years, court battles over ownership caused the park to fall into disrepair. Finally, in 1900, the Union Electric Company assumed ownership. With the name changed to Union Park, its golden age began.

L.D. Mathes, the park manager, led a massive resurrection of the park. New trolley tracks made access much easier. A lighted trolley from Nutwood Park along Highway 52 now sounded a bell on arrival at the park. Cement sidewalks allowed visitors to stroll the pathways in their Sunday best clothing. The dance hall received improvements, a new floor restored the bowling alley and a modern electric lighting system enhanced the experience for everyone.

In 1904, a new and larger dance hall known as the Pavilion began holding dances every weekend and on Wednesday nights. A favorite was the Bowery Dance; while the band played, park employees collected nickels from young men, who then chose their dance partners. A rustic bandstand made of gnarled tree branches added in 1905 provided a home for the Dubuque Military Band and Orchestra. In 1907, a larger bandstand provided hundreds of benches in a semicircle for concert goers to enjoy two performances each day.

The park superintendent, Joseph Bonz, affectionately known as the "Big Boss," and his family lived near the Loop or trolley landing. He mowed the lawns, planted the flowers, tended the greenhouse during the winter and was responsible for all necessary repair work.

More land purchased in 1908 allowed the construction of a children's playground modeled after the famous Ogden Park Playground in Chicago. Carousels, swings, slides, sandboxes and a pavilion for outdoor parties provided hours of enjoyment. Children visiting the park wore their Sunday best clothes while riding to the park on the trolley, changed into play clothes

at the park and then changed back into their best clothes for the ride home. Appearing in public in your everyday clothes simply was not acceptable. A wading pool twenty-five feet wide and sixty feet long at a depth of three inches to one foot added to the fun in 1910.

Not the favorite of parents but loved by the children, the wooden roller coaster provided thrills as it wobbled back and forth. Men riding the coaster almost always lost their straw hats. As the hats sailed into the fish pond near the coaster, enterprising young boys charged a nickel to retrieve them. Another popular attraction, the Wonder Cave, invited curious patrons to explore its interior with lighted stairs leading to the entry. Inside the cave, pathways led through the former lead mine, providing visitors with a look into our mining past, complete with artifacts left behind by the miners.

Added in 1909, the Mammoth Theater stretched across the valley from one hillside to the other. The largest theater in Iowa, it held 1,500 seats costing from ten to fifteen cents, depending on location, with an additional five thousand available free hillside bleacher seats. The excellent acoustics permitted even those on the hillsides to hear the performances. Acting companies from Chicago and New York performed on the Mammoth Theater's gigantic stage. In 1911, vaudeville entertainment joined the plays and concerts.

To further enhance the park's ambiance, one thousand rose bushes, huge beds of peonies and magnolia trees lined the pathways. Graduation parties, birthdays and family reunions were common at Union Park during this golden age from 1911 to 1919.

The weather forecast for Wednesday, July 9, 1919, called for fair to partly cloudy skies with the possibility of a thunderstorm in the late afternoon. A family reunion planned for the day brought people of all ages, and while children changed into their play clothes, the adults unpacked the food. When the rain started to fall, the children were told to change back into their good clothes and return to the pavilions. The rain rapidly became a downpour. The Mammoth Theater served as a dam, blocking the flow of the creek. When the water broke through the theater, the small creek became a raging river. The water rose an inch a minute. Quickly, water washed over the railings of one of the pavilions, causing Arletta Mitchley, age eleven, to fall into the water. She remembered that an angel grabbed her and placed her on top of the carousel. In reality, these angels were park employees who had tied ropes around their waists and jumped into the flood, which had reached twenty feet deep, to rescue victims. Without their bravery, many more would have perished. Five people died. Buildings were destroyed. With

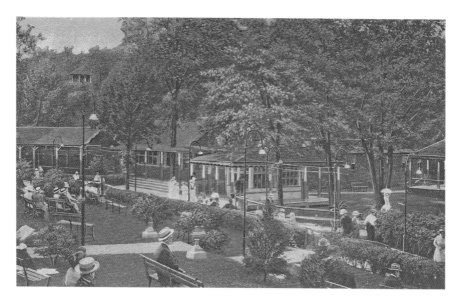

Center view of a Union Park postcard. *Author's collection.*

all communication down, the news did not reach the public until the next day. Union Park was a sea of mud.

On July 13, 1919, the park reopened, despite not being totally cleaned. The picnic grounds, roller coaster and dance pavilion opened. The destroyed buildings were rebuilt almost exactly like the originals. The pavilion, now called the "Death Pavilion," that had been swept away, carrying its occupants into the water, and the Mammoth Theater were not restored.

A new dance hall using the floor from the Mammoth Theater opened on July 26, 1923. It was hailed as the largest dance hall in Iowa. The year 1923 also saw the addition of a swimming pool with the gigantic dimensions of 150 feet by 50 feet with a 23-foot-high diving board and slides. The women's bathhouse boasted hair dryers. A roller rink named the Rinky Dink, along with all the other improvements, although popular, could not save Union Park.

Cars now made travel easier. Eagle Point Park, with its fantastic views of the Mississippi River, offered competition, and memories of the flood lingered. This new modern generation no longer considered Union Park a destination. Interstate Power Company bought the park, as well as Dubuque Electric Company, in 1927. Union Park closed in 1934. Buildings were dismantled. The roller coaster became a barn on my family's farm. The dance hall floor was moved to the Melody Mill Dance

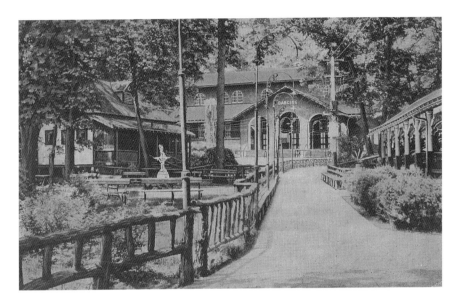

Union Park walkway postcard. *Author's collection.*

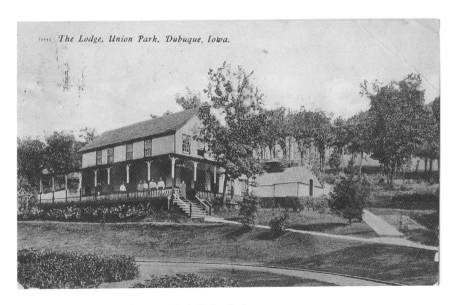

The Lodge at Union Park postcard. *Author's collection.*

Hall along Highway 52. Artifacts were sold or carried away. A statue of a girl and boy standing under an umbrella now sits in the courtyard of the Ryan Mansion in Dubuque.

The YMCA and Boy Scouts bought the property in 1946, but the Boy Scouts decided to build their own campground. The YMCA Youth Camp now provides opportunities for children in the Dubuque community to enjoy nature much as William Stewart had hoped more than one hundred years ago.

Eagle Point Park, located off Shiras Avenue, offers spectacular views of the Mississippi River, the Wisconsin bluffs and the Zebulon Pike Lock and Dam. Thousands of visitors enjoy watching barges move up and down the river through the locks. Charles M. Robinson, a journalist and secretary of the American Park and Outdoor Association, visited Dubuque in 1907. He is often quoted as having said, "I have never seen a place where the Almighty had done more, and mankind less, than Dubuque." He recommended a large park with a scenic view "so tired city dwellers" could experience "the greatest possible urban contrast."

Joseph A. Rhomberg owned ninety-five acres of prime bluff-top property. In his will, he bequeathed his property to his wife, Catherine, with the wish that this bluff area be sold only to be used as a park or other public space rather than for residential use. In 1908, Judge Oliver Shiras chaired a committee to create a park. Property was purchased from the Rhomberg estate, and the park opened in 1909. Judge Shiras deferred the request to name the park after him and urged the city to name it Eagle Point Park after a legend surrounding the area. According to the story, several young eagles were captured after a tree with their nest was cut down in New York. A local businessman there raised one of the young eagles. A local silversmith banded the eagle before it was released. The story continues that the eagle was later shot by an Indian from the bluff overlooking the Mississippi River. As news of the eagle with the silver band circulated, the bluff became known as Eagle Point.

More land was either purchased or donated to increase the park's size to 164 acres. A fence to protect against falls down the bluff, hitching posts for the horses and picnic tables added to the park's desirability as a spot for reunions, picnics and escaping the heat during the humid summers. The trolley extended its line to the park entrance in 1912, and stairs to Rhomberg Avenue added access.

The Stock Market Crash of 1929 led to the Great Depression of the 1930s. Most of Dubuque's factory workers lost their jobs during the Depression, farmers lost the market for their produce and only the wealthiest of citizens escaped desperation. To provide relief for the unemployed, the Works Progress Administration provided funds to build roads, parks, bridges

and other public buildings. Eagle Point Park benefited, as architect Alfred Caldwell was hired to design buildings and structures within the park. He hurriedly drew his plans in one night, presented them to the Park Board and was hired as architect and supervisor. Two hundred workers constructed the lovely limestone structures following the Prairie style of architecture reminiscent of Frank Lloyd Wright. The rock walls, fish pond, Indian council rings, Bridge Complex, Terrace Room, Veranda Room, restrooms and Indian Rooms provide both the physical setting for many celebrations and also a visual feast. Each of these constructions appear to grow out of the landscape rather than being built on it.

In 1933, the Neuman (also spelled Newman) log cabin—built in 1827 and supposedly the oldest cabin in Iowa—was moved to the park from its location on Locust Street. According to tradition, Father Samuel Mazzuchelli offered the first Mass in Dubuque in this cabin, and Ansel Briggs spoke there on his way to his inauguration as governor of Iowa in 1846. William Newman (Neuman) was an early settler of Dubuque who purchased the cabin in 1834. The cabin is further surrounded by myth because it was believed to have been built by a miner married to a daughter of Black Hawk of the Sauk Indians. There is no proof of this version of the tradition, but it is a

Eagle Point fish pond postcard. *Author's collection.*

High Bridge from Eagle Point Park postcard. *Author's collection.*

Eagle Point Bridge, also known as High Bridge. *Author's collection.*

Eagle Point Park Pavilion postcard. *Author's collection*.

good story because the miner apparently was a proficient ventriloquist who convinced the Indians of his "magical powers," thus providing a safe haven for other miners who were illegally mining lead. The cabin was used as a park pavilion until 1967, when it was moved to the grounds of the Ham House Museum. The cabin serves as an excellent example of the dogtrot cabin style of construction that separated the living and working sections of a cabin with an open area covered by a roof to provide protection from rain and help cool the cabin during the hot, humid summers.

Today, Eagle Point Park includes a small wading pool, a band shell, horseshoe pits, tennis courts, a volleyball court and a softball field. A hiking/biking roadway has been added from the Ham House Museum to the park's entrance as well. In 2004, Eagle Point Park was recognized as an influential structure in the state of Iowa. The future may allow for a restoration of the rock structures to the historical accuracy of Alfred Caldwell's "City in a Garden," which he believed the structures created surrounded by park or garden landscapes.

The completion of the lock and dam changed the view from Eagle Point Park. Kimbel's Park disappeared under the deeper water created by the dam. Richard Kimbel had built an amusement park on the island that existed before the dam. He also ran the ferry carrying passengers to the park for five cents each way. Once on the island, customers enjoyed a dance hall,

a saloon, gambling, free food and a variety of entertainment. Sundays were family days, but otherwise Kimbel's was known as a raucous, unruly and wild place.

Favorite entertainment on the island included a hypnotist who buried a willing participant, who was paid twenty-four dollars, six feet underground on a Thursday and retrieved him on a Saturday. The man survived by using a breathing tube. Another preferred amusement involved two white horses plunging thirty feet into the Mississippi River. On May 18, 1902, five thousand people crossed the new Eagle Point Bridge to enjoy a day of dancing and drinking with Dubuque's Saengerbund (German choral society) on Kimbel's Island.

Kimbel never used police to establish order as he was well known for being quite capable on his own. His large family, with twenty-three children, also lived on the island in a thirteen-room house. When Kimbel died, the property was sold and eventually disappeared under the river as the dam increased its depth.

All area towns offered amusements to entertain. Worthington held dances and concerts at the Imperial Gardens, and Granada Gardens in Sageville offered music, as did Rockdale at the Pavilion. To escape the summer heat, many families had cottages at Shawondasse along the Mississippi River. The city beach at Eagle Point opened at 9:00 a.m. with lifeguards Harold Petsch and Dell Lynn on duty. The beach had playground equipment, picnic tables, diving boards, showers and even a restaurant.

Henry W. Longfellow referred to Shawondasse in the poem "Song of Hiawatha" as the child of the Father of Winds of Heaven who received from his father the gift of the South Wind. According to the poem, "Shawondasse…Had his dwelling far to southward; In drowsy, dreamy sunshine; In the never ending summer." The owners of the land on the banks of the Mississippi River near Massey Station south of Dubuque intended the resort to be a tribute to those endless days of summer when they incorporated in 1889. Families owned cottages there but also enjoyed a communal kitchen and dining hall with cooks, waitresses and housekeepers. The Victorian-style cabins with their screened porches sat high on a hill with a beautiful view of the river. Steps to the beach and private docks allowed each family to enjoy the pleasures of summer river life. If desire or necessity required a trip to Dubuque, the Milwaukee Railroad that ran behind Shawondasse provided passenger service if a flag notified it to stop.

The Great Depression of the 1930s ended the camp. Cabins were sold to private owners, replaced or simply torn down. Those families lucky enough

The road from Kimbel's Park to Potosi, Wisconsin. *Author's collection.*

to acquire a cabin continued to enjoy the river and those "never ending summer" days.

Of course, the circus was always a main attraction, as it remains today. Those who could not afford the price of a ticket still enjoyed the loading and unloading of the animals and wagons when the circus train with eighty-five double-length train cars arrived. A 1909 circus parade— including seven

Shawondosee cabins. *Courtesy of Dubuque Center for History, Loras College, Gerda Preston Hartman Collection.*

A circus parade in Dubuque. *Courtesy of Dubuque Center for History, Loras College.*

hundred horses, forty elephants, thirty camels and all the accompanying equipment on colorful wagons—delighted all ages when Barnum and Bailey came to town.

Despite the lack of all the modern devices of entertainment, residents of Dubuque County managed to enjoy their communities with fun-filled activities.

MINISTERS, PRIESTS AND BISHOPS

Conversion of a Frontier

According to the *1880 History of Dubuque County*, "There was little of the religious element, almost no fear of God or regard for man. A more loose and godless community than this is described to have been could scarcely be conceived of. There was no recognition of the Sabbath as a day of rest, and immorality in every form was both openly and secretly practiced" in the area that is now Dubuque County. A visitor who wished to "read the Bible had to travel to Galena to find one." Obviously, the author of the *History* was overjoyed to report that several religious families moved into the region.

Barton Randle, a Methodist minister, crossed the Mississippi River in 1833 to establish a Dubuque mission. On November 6, 1833, he delivered the first sermon in Iowa at the Bell Tavern, where the Julien Hotel is now located. A log meetinghouse located on the present site of Washington Park was dedicated on August 23, 1834, at a cost of $225, raised by seventy subscribers. Methodists, as well as other denominations, met there for services. The building also housed the first public school and the first courthouse, where the incorporation papers for the City of Dubuque were signed.

The Centenary Church on the corner of Seventh and Locust Streets opened in 1839 to commemorate the 100th anniversary of the founding of the Methodist Church. Quickly outgrown, a larger church on Main Street replaced the Centenary Church. This brick building between Eleventh and Twelfth Streets housed a seventeen- by twenty-four-foot organ encased in black walnut.

A rapidly growing congregation needed a larger church after forty-two years, so the planning for a new building began under the direction of Dr. George M. Staples. Unfortunately, he died before the completion of the building, but to honor the "beloved physician" the congregation named the church St. Luke's since Luke the Evangelist was a doctor. Its dedication on May 16, 1897, began another chapter in the religious history of Dubuque.

Built in a Romanesque style with limestone from Indiana, St. Luke's is best recognized for the beautiful Tiffany windows that adorn the church. These windows illustrate the earliest, as well as the last, works of Louis Comfort Tiffany. Art Feminella, a Tiffany glass expert, described the windows as "the equal of the best found in an ecumenical setting. The studio's full arsenal of artistic weapons has been unleashed and the resulting barrage of color, light, and line is quite a scene to behold. An extraordinary glass, rippled glass, drapery glass, etched flashed glass, and textured, rolled glass can be seen throughout the opalescent windows. The light floods through openings cut into the blocks of stone, transforming lumps of glass and strips of lead into brilliant jewels of light. The mood is restful, the effect quite spiritual." The largest of these windows, located above the balcony on the east wall, depicts the unknown author of the Book of Job in memory of Jesse P. Farley, who had joined the log church in 1835. The Richardson family donated the window above the altar known as the Angel among the Lilies. It portrays the face of their daughter Harriet, who died at the age of eighteen.

During the winter of 1835–36, Presbyterian minister Reverend Cyrus Watson preached in the log cabin church. Believers founded an Episcopal church in 1838. Although short lived, it was later replaced by the St. John's Episcopal Church located on Locust Street. The First Congregational United Church of Christ, located at Tenth and Locust Streets, began on May 12, 1839. Reverend James A. Clark organized fourteen women and five men who adopted the Congregational form of governance on December 12, 1844. The Old Stone Church located near Washington Park provided accommodation for services, but growth was slow, with only nineteen members by 1843. Lack of funds resulted in the loss of the Old Stone Church in 1844. Holding services in the courthouse, the congregation began to raise the funds for a new building. The Reverend Holbrook toured New England states collecting money, while in Dubuque, the congregation rented or sold pews to members. By 1849, the congregation was self-supporting. After purchasing two lots at the present site of the church, the church sold its lot across from Washington Park to Jesse P. Farley, who then built the family mansion next to the bluff on the site. The congregation

laid the cornerstone for the new church in July 1856, but construction was interrupted by the Panic of 1857 and the depression that followed. By 1858, services could be held in the basement, but a $5,000 loan allowed construction to be completed for the dedication on April 1, 1860. The church's rose window on the southern wall over the entrance is one of the building's most distinguished features.

Sunday school parades and picnics began in Dubuque in 1908 under the direction of John E. Hedley, who served as president of the committee to organize the events. At first, the picnics were held in Union Park but later moved to Eagle Point Park. First Congregational and Immanuel Congregational Churches worked together for the 1931 parade to field a total of eight floats. Ten thousand people attended the 1931 picnic held at Eagle Point Park. After twenty-five years, the picnics and parades ended in 1934.

The Baptists formed a church in 1840. In 1841, they met in a small building on Clay Street (now Central Avenue). A group of disciples or followers of Alexander Campbell created a nondenominational sect that advocated a return to Christianity's roots and purchased the Old Stone Church for its services in 1844. In 1848, the German Presbyterian Church began services under the direction of the Reverend Fleury from Switzerland, and in 1854, St. John's Evangelical Lutheran Church organized.

Most residents of Dubuque County were Catholic due to the number of Irish and German Catholic immigrants, but few priests were available on the frontier. The Dubuque lead mine region was in the Detroit diocese, so administration was extremely difficult. In 1833, Charles Van Quickenborne, a St. Louis Jesuit, arrived at Dubuque. He had been sent by Bishop Rosati of St. Louis to assess the situation for Catholics at the lead mines. He organized the Irish into a congregation and formed a committee to build a church. In 1834, Reverend Charles Fitzmaurice became the new pastor for Dubuque and Galena. Unfortunately, he fell victim to cholera.

Samuel Mazzuchelli, a young priest from Italy, arrived in Dubuque via Wisconsin while on his way to Cincinnati on the Ohio River. He returned to Ohio after a short stay in Dubuque and Galena but was sent back soon. He had managed a trip of almost 1,500 miles in 1835—no small feat considering the lack of roads and inadequate means of transportation on the frontier. The Irish miners convinced him to stay. They affectionately called him Father Matthew Kelly, as the Italian name was not to their liking. Father Mazzuchelli served as the only priest in the area other than a few missionaries to the Indians in the far North.

This page: A Sunday school parade in Dubuque. *Courtesy of Dubuque Center for History, Loras College.*

The Sherrill, Iowa float in the Sunday school parade. *Courtesy of Dubuque Center for History, Loras College.*

Father Mazzuchelli held services in the home of Patrick Quigley while drawing up plans for a church in Dubuque and building St. Michael's in Galena. On ground donated by Quigley, Mazzuchelli laid the cornerstone of St. Raphael's Church, named after the archangel in July 1835. During the ceremonies, Milo H. Prentice, a Protestant, delivered the main speech. It is worth noting that the Protestants of the community had contributed to the building fund as well as the Catholics. The forty-by seventy-nine-foot stone structure was located south of the present cathedral site. Father Mazzuchelli lived in a room under St. Raphael's or boarded with members of the congregation. During his stay in Dubuque, he met Mr. Le Claire of Davenport, Iowa, to the south. Mazzuchelli said Mass at his home and convinced him to donate four city blocks for the construction of St. Anthony Church to serve the forty Catholic families living in Davenport. When Bishop Loras arrived, St. Raphael's became a cathedral and Father Mazzuchelli moved across the Mississippi to Wisconsin.

There he founded St. Thomas College of Sinsinawa in 1847. In 1866, it became St. Clara Academy for women. He also founded the order of Dominican Sisters of the Congregation of the Most Holy Rosary at Benton, Wisconsin. Father Mazzuchelli built St. Augustine Church in New Diggings, Wisconsin, as well as other churches and civic buildings. He even met with Joseph Smith in Nauvoo, Illinois, before the Mormons left for Utah. Father Mazzuchelli returned to Dubuque in 1858 to deliver the eulogy at Bishop Loras' funeral. While visiting a sick parishioner in 1864, he contracted pneumonia and died in Benton, Wisconsin. He is buried there in St. Patrick's Cemetery. In 1993, Pope John Paul II declared Mazzuchelli Venerable with heroic virtues and a servant of God in the first step to sainthood.

Jean Mathias Loras, born in Lyon, France, became a priest in 1814. His father, who most likely was his inspiration for entering the priesthood, had been a wealthy merchant in Lyon. He was killed during the Reign of Terror of the French Revolution in 1792. Father Loras decided to answer a call for foreign missionaries in Asia, but after meeting Bishop Michael Portier of Mobile, Alabama, he decided his destiny lay in America. Following his consecration as a bishop in 1837, Loras returned to Europe seeking funds for the American Catholic Church. Due to his connections, especially with the Leopoldine Society of Vienna in Austria, he was able to secure much-needed financing. As an honor to the society, he persuaded the German Catholic population west of Dubuque to name its community New Vienna. Many Americans opposed the efforts of the Leopoldine Society to fund the American Catholic Church. Samuel Morse, who invented the telegraph, believed their efforts to be part of a conspiracy and devoted his life to opposing the Catholic Church.

On April 18, 1839, Bishop Loras, along with Father Mazzuchelli, who had met him in St. Louis, and Fathers Joseph Cretin and Antony Pelamourges, arrived in Dubuque. In order to establish churches, schools and other needed religious institutions, Loras purchased thousands of acres with the funds from European missionary societies. Father Gretin continued on to Minnesota and Pelamourges to Davenport. Of the four seminarians who had planned to join Loras on the frontier, only one could withstand the pressures of the wilderness. A lack of priests constantly plagued Bishop Loras.

Ethnic tension provided an additional problem for Bishop Loras in the Dubuque region. Most of the Catholics were German and Irish immigrants, with only a few descendants of the French fur traders. The German Catholics wanted sermons delivered in German, not English or Latin. The problem became so severe that German members of the Church of the Assumption

in Lattnerville attended Lutheran services rather than mass, as the Lutheran sermons were preached in German.

Another issue involved temperance. Bishop Loras—although from a French upper-class family who drank wine with meals, owned a vineyard and made their own wine—understood the problems caused by abuse of alcohol. He took the temperance pledge and encouraged his clergy and laity to follow suit. His directive was not well received among his German and Irish parishioners. When he placed a grocery that dispensed alcohol in New Vienna under interdict for several years, thus prohibiting Catholics from entering, it was mostly ignored.

Despite these issues, Bishop Loras was respected and able to build churches, add priests and meet his special goal of Catholic education. Each church had at least a room for a school. These schools needed teachers. The Sisters of the Blessed Virgin Mary arrived in 1843 to fulfill this need. A major dream of Bishop Loras was to have a seminary in the diocese. For this purpose, Mount St. Bernard's was founded at Key West, just to the west of Dubuque, in 1850. Funds and priests never materialized, so the seminary closed in 1856 on the order of the St. Louis Province. In 1937, a seventy-five-foot cross was erected near the site of the former seminary to commemorate the 100th anniversary of the archdiocese of Dubuque. In 1963, the Knights of Columbus added blue neon lights to the cross. It shines still to mark the site on the south side of Dubuque at Key West.

When Bishop Loras traveled twenty miles west to Pin Oak to minister to a dying man in 1842, he stayed at the Pin Oak Tavern located along the main road between St. Paul and Dubuque, where the land office was located. John Floyd had been a friend of Thomas McCraney, but unlike McCraney, who stayed in Dubuque, Floyd headed west for the rich farmland available on the edge of the prairie. He bought six hundred acres and became one of the wealthiest settlers of Dubuque County and postmaster for Pin Oak. He installed shelves and a door on a hollow oak tree on the grounds of the inn as the first post office. The planks that were to be his front door became the coffin for Kaintuck Anderson, who was shot in Durango by Adam Sherrill, so he spent the first winter without doors. He later built a three-story tavern known as the Western Inn. He insisted on using the word tavern rather than saloon because he never served alcoholic beverages. Taverns were a place to stay, visit or get a meal. Saloons served alcohol.

While at Pin Oak, Bishop Loras blessed a plot of land to be used for the man's burial. The man's sons built and erected a twelve-foot cross on the site. Settlers built a log church there in 1843, and Loras secured title to forty acres

Above: Pin Oak Tavern. *Author's collection.*

Right: Pin Oak Tavern sign. *Author's collection.*

Left: The Floyd Tavern of the Western Hotel is on the National Register of Historic Places. *Author's collection.*

Below: The interior of the Floyd Tavern, with a replica statue of the Wells Fargo Stage that stopped here. *Author's collection.*

for the future construction of a larger church, rectory and school. A new stone church in the shape of a cross was built in 1852. It later became the parish hall. A new, larger brick church replaced the stone structure in 1888. In 1855, Pin Oak's name had changed to Georgetown in honor of George Gallon, a local landowner, and in 1898, it changed again to reflect the new church: Holy Cross, Iowa.

Bishop Loras suffered several strokes in the fall of 1857. He died on February 19, 1858, having grown the diocese to fifty churches, forty-seven mission stations, thirty-eight priests, a Trappist monastery and three religious orders. His remains were interred in the mausoleum beneath the cathedral.

A "Godless community" no longer, Dubuque County churches continued to grow and thrive.

STRONG-MINDED WOMEN

D uring the nineteenth and early twentieth centuries, Dubuque grew from a small mining settlement to a thriving city of lumber mills, meatpacking plants and breweries. New neighborhoods expanded the limits of the city while new schools, banks and stores expanded educational and economic boundaries. Steamboats continued to provide transportation, but the railroads extended travel to all areas of the growing country. The telegraph connected the citizens of this once remote mining community to the entire world. In town, the trolley lines allowed residents to move about the city with more ease. To lead us into this new modern world of technology, ideas and progress, Dubuque provided many hardworking, well-educated and assertive women who, unfortunately, are not well known and have been little appreciated or celebrated.

Bertha Heustis was just such a woman. Born in Michigan on March 5, 1870, and married to Dr. James W. Heustis in 1895, she traveled, wrote short stories and poetry, composed lyrics for musical compositions, worked as a newspaper correspondent, lectured and advocated for women's right to vote. While living in Dubuque, Dr. and Mrs. Heustis resided at 1030 Grove Terrace. Being financially secure, enjoying domestic help and without children, she had the time (always a difficult balancing act for women) and ability to work for her community and country.

According to the *Atlantic Monthly Magazine* of November 1903, Heustis "touched the hearts of all present" with her rendition of "The Star-Spangled Banner" at the October 8, 1903 Iowa Daughters of the American Revolution

Convention in Davenport, Iowa. The Iowa DAR had one thousand members and awarded prizes to schools and students for essays pertaining to history topics. It also gave flags and patriotic pictures to schools, made donations to charities and located and memorialized the graves of Iowa soldiers who had fought in the Revolutionary War.

Heustis penned the script for the only silent movie to have as its cast all hearing-impaired actors. *His Busy Hour* (1926), produced by James Spearing, was never released, although it was made for a general audience. In 1926, it was shown at the Lexington School for the Deaf in New York City. A print of this film was found in 1981.

In April 1910, at the nineteenth Continental Congress of the Daughters of the American Revolution, Heustis represented Dubuque and explained the local chapter of Children of the Republic. This organization, sponsored by the DAR, involved forty boys ages ten through fourteen who were uniformed and drilled by Captain Higbee and Lieutenant Ellsworth. They participated in parades, historic celebrations and patriotic displays. At this same congress, their guest speaker, President Taft, was introduced with heavy criticism for not supporting women's suffrage. Flustered, he gave his scheduled address.

In 1992, Heustis was honored as a member of Who's Who Among Women of California, where they lived for a short time before returning to Dubuque. She belonged to a host of organizations, including the National League of American Pen Women, of which she was president while living in Washington, D.C.; Woman's Relief Corps; National Press Association; and Women of the Civil War. She died on January 21, 1944, and is buried next to her husband in Arlington National Cemetery.

Mary Newbury Adams was born in Peru, Indiana, in 1837 to the Reverend Samuel Newbury and MaryAnn Sergeant Newbury. She graduated from Cleveland public schools, where she benefited from studying under the direction of Emerson White, an exceptional teacher and inspiration for Adams.

White was born in Ohio in 1829 and served as a teacher, principal and superintendent. In 1863, he was named state commissioner of common schools. From 1876 to 1883, he was the president of Purdue. He also edited *Ohio Educational Monthly* (1861–75) and *National Teacher* (1870–75). His most famous published textbook was *Elements of Pedagogy*. He was known for his kindness, encouragement and expertise. He once had a student who was an excellent scholar, and no matter what assignments or how often he was sent to the board to do work, he always finished and then was the source of great

mischief. White told him to help other students and told the other students that they should always need help. It worked. After retirement, he lived in Columbus in a beautiful home given to him by that same problem student, John D. Rockefeller, in gratitude to the teacher who knew how to "manage a mischievous boy." Emerson White was the main inspiration for Mrs. Adams. They had few female models.

At eighteen, Mary Newbury graduated from the Emma Willard Seminary in Troy, New York. She married Austin Adams, a young lawyer, and when she was nineteen, they moved to Dubuque. He later became a judge of the Iowa Supreme Court. As chief justice of the Iowa Supreme Court in 1880, he was the first to allow women to practice law before the court. Their son Eugene Adams purchased an interest in Roberts and Langworthy Iron Works. He acquired Roberts's interest in 1885. In 1892, his brother Herbert bought out Langworthy's interest, resulting in the founding of the Adams Company.

According to Louise Noun, author of *Strong Minded Women* (1969), Mary Adams, as a founder of the Republican Party in Dubuque, "was an ardent Women's rights advocate." The Iowa Federation of Women's Clubs originated as a study club founded by Mrs. Adams in 1868 to increase women's knowledge and education. Although a staunch suffragette, she believed the right to vote was useless unless women had access to education and information. She founded the Northern Iowa Suffrage Association, the first suffrage group in Iowa. In 1981, she was named to the Iowa Women's Hall of Fame.

Mrs. Adams delivered an address entitled "Influence of the Great Women of Yesterday and the Civilization of Today" at the Congress of Women during the 1893 World's Colombian Exposition in Chicago, Illinois. She defined these "great women" as having "a great mind that could think, one that could reason, one that could invent, one that could have foresight, save the grain today to plant next season, plant the clover to keep bees and the cows close at hand; one was great who built the hut before the winter and storm came or who carried the stone hatchet in case the wild beast is met." She believed the exposition served to "carry us forward to new convictions for duty and elevate the rule of life." She continued, "Our horizon has broadened and the little we know is put into comparison with the infinite we do not know. This collection from all races, with exhibition of their endeavors to civilize and attain enlightened humanity, would be a childish, summer play of the nations if it were not a profound examination of civilization, its causes, and its growth."

Adams quoted the poem "Corn" by Sidney Lanier when she stated that women "mutually leaven strength of earth with grace of heaven." She included the words of poet George Eliot in her poem "Spanish Gypsy" of 1864: "The soul of man is widening toward the past, more largely conscious of the life that was here is the pulse of all mankind feeding an embryo future." Both these quotes served to underline her belief in the importance of recording the history of women rather than only the "great" deeds of men.

She delivered another speech at the International Congress of Anthropology, also at the Chicago Exposition of 1893: "The Influence of the Discovery of America on the Jews," which dealt with the anti-Semitism of Europe and the freedom offered by America, as well as the debt the U.S. legal structure owed to Judaism. She said:

> *The republic founded on unity in variety was an opportunity for the Hebrews to rejoice in. A government under which the president takes his oath as chief magistrate by putting his hand on the collected literature of the Jews, sanctions the collected wisdom of the people as authority. Here is the opposite of the ideal in Europe that persecuted the Jews. Here the president is but the executive hand to put into effective force the will of the people and these laws are put into permanent form as the people's best friends. No supernatural Atlas holds the government on his shoulders, no individual can say "It hath been written but I say, do as I, the individual shall think right." The written law, as with the Hebrews, is the method of the republic and not the command of one leader or the example of one person. The "elders" of the people must rule, not by sentiment but by written law. The Prophets had given promise to the coming republic variety in harmony, not imperial uniformity.*
>
> *We want a history of civilization written showing the work of women for the benefit of common life, of civil peace and religious aspiration they being women blessed by the Holy Ghost who had faith in the divinity of the human soul and were mothers of more than animal life. They gave vitality to souls by faith and thought.*

As a result, the Jewish Women's Congress was founded that year.

Adams was friend to and corresponded with many reformers and intellectuals during the mid- to late nineteenth century—the Alcott family, Amelia Bloomer and Susan B. Anthony, among them.

Bronson Alcott met Adams through her sister, who married the governor of Michigan. Alcott visited Dubuque in December 1870 and again in 1874

at the invitation of Adams. Mr. Alcott, a famous transcendentalist and education reformer who abhorred corporal punishment for students, and his wife continued a lifelong correspondence with Mr. and Mrs. Adams. He said of Mrs. Adams, "She is the representative woman of the West" and "a prophetess or 'Sibyl.'" She visited the Bronson family at their home in Connecticut during 1872. Both Mr. Bronson and Mrs. Adams were Unitarian Universalists, which is a liberal religion with Jewish-Christian roots. It has no creed. It affirms the worth of human beings, advocates freedom of belief and the search for advancing truth and tries to provide a warm, open, supportive community for people who believe that ethical living is the supreme witness of religion.

Bronson Alcott and Mary Newbury Adams erected a cairn or monument to the memory of Henry David Thoreau in 1872 at the site of his cabin. This cairn became a pilgrim's shrine. The Thoreau Society, dedicated to the exploration and preservation of knowledge, was organized in July 1941.

Mary Newbury Adams advocated tirelessly for women's equal education and political rights. She was a leading suffragette along with Susan B. Anthony, Elizabeth Cady Stanton and Amelia Bloomer. Mattie Brinkerhoff was also a popular suffrage lecturer throughout the Midwest. The *Dubuque Herald* stated, "Mrs. Brinkerhoff's speech was logical, not sensational but earnest and truthful. What she says will be remembered." But it was not. Mrs. Adams provided the answer. Mrs. Brinkerhoff divorced her husband and remarried, which, according to Mrs. Adams in a letter to Amelia Bloomer, "hurt our cause here in Iowa."

Mrs. Adams died on August 5, 1901, in Dubuque. In order to ensure a better education for children, she donated all her books to country schools. She had sown the seeds of the Dubuque County Library. As with many of her colleagues in the suffragette movement, she did not live to see women vote legally. Her legacy for the advancement of women's rights, education, freedom of thought and community improvement did establish a firm foundation for later reforms.

Another avid reformer, Clara Aldrich Cooley, was born in Vermont in 1830. She married Judge D.N. Cooley and raised four children to adulthood. Her husband was the former law partner of Austin Adams and a Republican state senator from the predominantly Democratic Dubuque.

In 1900, Mrs. Cooley represented Iowa at the Paris Exposition. Both Speaker of the House Henderson and Senator Allison from Dubuque endorsed her in this position. Her speech, entitled "Women in Science,"

received many accolades. She founded the Dubuque branch of the Daughters of the American Revolution, the Dubuque Ladies' Literary Association and the Home for the Friendless. She also possessed a national reputation as a Bible teacher with a record of leadership in religious and philanthropic interests.

For her work as the founder of the Dubuque Woman's Club, she was elected an honorary member of Sorosis, the first professional women's club in the United States, and the General Federation of Women's Clubs elected her honorary vice-president. Sorosis, an organization of professional and literary women was founded in New York City in 1868, when female journalists were denied tickets to a New York Press Club event honoring Charles Dickens. Club members feared that the presence of women would make the meeting "promiscuous." Sorosis was named after plants with a grouping of flowers that bore fruit, symbolizing women who, rather than being weak and delicate, can achieve great deeds for society.

Eventually, Sorosis members formed the Association for the Advancement of Women in 1873. They worked for suffrage, prison reform, temperance and peace. In an effort to create unity among the diverse members, suffrage was not discussed formally, but many members were active in the suffragette movement. Clara Aldrich Cooley was one of its first officers. Cooley died on November 16, 1925, but she was able to witness the fruition of one of her life-long goals: suffrage for women.

Susan Ann McCraney was born in Dubuque on January 10, 1833. She was probably the first non-Indian child born in what was to become Iowa. Her parents, Thomas McCraney and Susanna Slayton McCraney, had ventured illegally to the west side of the Mississippi River to mine lead. Since the area was Indian territory, soldiers drove out the miners, but as Mrs. McCraney was pregnant, they returned to a cabin that had escaped the soldiers' attempt to burn all illegal structures. After Susan's birth, they were once again removed from the lead region.

Thomas McCraney was born in New York, fought in the War of 1812 and served as a member of the General Assembly of the Territory of Wisconsin. Susanna Slayton was born in 1798 in Vermont. They were married in New York in 1814. Both the Slayton and McCraney families moved to Illinois, where Susanna's father died in Quincy in 1823. Susanna's mother then moved with the McCraney family to Jo Daviess County, Illinois. Along with other members of the family, Susan became title holder to many acres of Dubuque County. As speculators, the McCraney family purchased unimproved land from the government once the area was ceded by the Native Americans and then sold off portions, including my family's century farm, to settlers.

Susan grew up in Dubuque and attended the first school with Mr. George Cabbage as teacher. In 1841, scandal enveloped the family when Thomas divorced Susanna to marry his son's mother-in-law. On December 11, 1855, Susanna McCraney filed suit against the estate of Thomas McCraney, who had died that year. She claimed that the divorce was fraudulent and should be set aside. The suit was successful, and she recovered one third of his estate. She died in McGregor, Iowa, on February 9, 1868.

In 1851, Susan married John S. Brynes. They purchased a farm in Whitewater Township, south of Dubuque near Cascade. They raised nine children there. She died in 1894 and was buried next to her husband in St. Mary's Cemetery in Cascade. On May 29, 1996, a tombstone for Susan Ann McCraney Brynes was dedicated at the cemetery. Susan McCraney represented the transition of Dubuque from frontier to mining town to farming community. Her hard work and devotion to her family helped to establish a stronger community for those who followed.

The Carnegie Stout Library offers for sale notecards or eight-by-ten prints with images of historic sites, many of which no longer exist. These images are taken from the copperplate etchings of Kate Keith Van Duzee. Van Duzee, born in Dubuque on September 18, 1874, lived her entire life in Dubuque with the exception of her art studies. She studied in Boston and Ipswich, Massachusetts, and Stone City, Iowa. Grant Wood and Thomas Hart Benton number among her associates. She founded the Dubuque Art Association in 1910.

Art was not her only interest. She was especially concerned about the welfare of children. In 1900, she helped to found the Dubuque Boys Club, whose first meeting of thirteen boys was held at her residence at Fourteenth and White Streets. The Boys Club moved its location several times until purchasing a building at Ninth and Iowa Streets. In 1967, the urban renewal project destroyed the building, and the club moved to lots purchased on Thirteenth Street, where it remains today.

Van Duzee also served as a member of the board of directors at the Mount Pleasant Home for Orphaned Children for forty years. The home had been organized in 1874 by a group of fifty-three Dubuque women who closely supervised the condition of the home and the children. Originally located in the Graham House on Hill Street, in 1877 it moved to the Lovell Mansion, which had been donated, along with two acres, by owners Mr. and Mrs. James Griffith. Judge Lovell had been a prominent Dubuque miner, railroad promoter and land speculator, as well as a judge. The home had

gardens to produce its own food, as well as cows, orchards and vineyards. In 1957, the Mount Pleasant Home ceased being an orphanage, and its mission changed to providing a place of residence to single women aged sixty-five or older. In 1986, men were allowed to live there as well.

Kate Keith Van Duzee died in Dubuque at Bethany Home in 1962. Her art is displayed at the Carnegie Stout Library. She rarely sold any of her works, but when she did, all profits went to charity. Her efforts to beautify Dubuque and assist its youngest citizens continue to benefit the community.

After being a runner-up for the Newbury Award in 1930 for her novel *The Jumping Off Place*, Marian Hurd McNeely wrote a humorous poem called "Ballad of Losers." She was definitely not a loser, but her sense of humor concerning her "also ran" status was well known. McNeely, who was born in Dubuque on July 26, 1877, wrote articles for the *Telegraph Herald* from 1903 to 1906, as well as children's books and short stories. *The Jumping Off Place*, about a family of orphans who inherited a homestead on the Dakota prairie from their uncle and battled climate, frontier hardships and claim jumpers, was easily her most famous and still a favorite of readers.

She married Lee McNeely in 1910. They raised four children to adulthood. For a brief stint, they homesteaded at the Rosebud Indian Reservation in South Dakota. This experience provided the inspiration for *The Jumping Off Place*.

Marian Hurd McNeely died in 1930 after being hit by a car crossing a street in Dubuque. Her novels *Winning Out* (1931) and *The Way to Glory and Other Stories* (1932) were published posthumously. Her husband sent Christmas cards containing one of her poems each year until his death in 1960.

Caroline Graves Dexter arrived in Dubuque in 1835. She was the first female teacher in Dubuque and probably in Iowa. She began teaching in the log schoolhouse in March 1836. She was also the first woman to teach an Iowa Sunday school. She and her husband later farmed in Center Township, Dubuque County, where a hill bore their name, as did a one-room school at the top of Dexter Hill.

Born to William Lawther and Annie Bell Lawther on September 8, 1872, Anna Lawther attended Dubuque schools during her early years. Later, she attended Miss Stevens' School in Germantown, Pennsylvania. A graduate of Bryn Mawr, also in Pennsylvania, in 1897, she served as assistant bursar, a financial administrator. She also worked at Bryn Mawr as a warden of a residence hall and as secretary of the college until 1913.

Anna Lawther moved back to Dubuque, where she became involved in local political issues, especially women's suffrage. She chaired the Dubuque County Chapter of Equal Suffrage League. As an active feminist, she became the first woman to serve on the Iowa State Board of Education and the Iowa Board of Regents. Governor Harding appointed her to the Iowa Council of Defense in 1916. In 1940, she delivered the convocation address at the State University of Iowa—the first woman to do so. In 1985, she was named to the Iowa Women's Hall of Fame. Students at the University of Northern Iowa may recognize the residence hall named in her honor.

Despite her family's fears for her reputation, Lawther served on the board of directors of the Dubuque Home for Unwed Mothers. It later became the Hillcrest Baby Fold. Lawther remained on the board of directors for forty years. She worked tirelessly for the right of women to vote. In 1916, Dubuque County voted down a referendum to allow women to vote in Iowa by the largest margin in the state. Undeterred, she continued to lobby for the vote. Once the Nineteenth Amendment became law, she was elected as a delegate to the Democratic Convention both in 1920 and 1924.

Anna Lawther died in Dubuque on October 21, 1957. As testimony to her influence, her obituary appeared in newspapers throughout the United States.

With eighty-eight films to her credit, Margaret Lindsay, the daughter of John and Bertha Kies, won a role in the 1932 film *The Old House* with her very convincing English accent. She went on to star opposite Ronald Reagan in *Hell's Kitchen,* with Errol Flynn in *Green Light* and with Bette Davis in *Jezebel.* Her most well-known role was that of Hephzibah Pyncheon in the 1940 production of *House of Seven Gables* with Vincent Price and George Sanders.

Margaret Lindsay was the eldest of six children. Her father was a pharmacist in Dubuque. She graduated from the Visitation Academy in 1930 but then studied at the Academy of Dramatic Arts in New York. She made her film debut in England. While there, she attained her English accent. According to Lindsay, the knowledge that she was from Iowa would have killed her career, so she manufactured an English autobiography to accompany the accent. She appeared in films with James Cagney, Henry Fonda, Bette Davis, Humphrey Bogart and many others. Her last film was *Tammy and the Doctor* in 1963.

She lived with her sister in Hollywood and never married. Although she did not live in Dubuque during her adult life, her roots were most definitely in Dubuque. She died in Los Angeles in 1981.

Born in Boston, Massachusetts, in 1833, Nancy M. Hill graduated from Mount Holyoke College. When the Civil War began, she volunteered to serve as an army nurse attending to the wounded from Antietam, Chancellorsville and the Battle of the Wilderness. The surgeon of the medical unit advised her to attend medical school. She then enrolled at the University of Michigan Medical School—the only one to accept women. She graduated at age forty-one. She moved to Dubuque, where she became the city's first female doctor. She specialized in obstetrics from her office on Locust Street. She once stated, "I was never a mother, but I brought about 1,000 babies into the world."

In 1896, Dr. Hill founded the Women's Rescue Society, where she worked to assist orphans and unwed mothers. She often argued with the Daughters of the American Revolution, which she criticized for spending too much time on women's past achievements rather than moving women's rights forward. As president of the Dubuque chapter of the Women's Suffrage Association, she worked to elevate the legal, societal and financial conditions for women. Both famous and controversial, Doctor Nancy M. Hill was inducted into the Iowa Women's Hall of Fame in 1989. She died in Dubuque in 1919 and is buried at Linwood Cemetery.

Anna Blanche Cook, born in Indiana in 1874, worked with Dr. Hill to meet the needs of orphans and unwed mothers in Dubuque. She served as deaconess of Dubuque's St. Luke's Methodist Episcopal Church and helped to organize the Visiting Nurse Association. In 1914, at the request of Dr. Hill, she assisted in the establishment of the Baby Fold that provided institutional care for preschool children, helped to establish adoptive and foster homes of children and counseled unmarried mothers. In 1924, acting on a recommendation Cook had made earlier, the Baby Fold became the Hillcrest Baby Fold to honor Dr. Hill. Today, Hillcrest Family Services continues to fulfill that legacy with the original services, as well as an alternative school, adult and child wellness programs, mental health counseling, residential treatment facilities and emergency shelter and much more.

Women's accomplishments represented a shift in American culture. The consequences of that shift, since ideas do have consequences, touched every part of the personal and social lives of Dubuque residents, as well as those of the country. Dubuque women most definitely helped to carry us forward into a new era.

Chapter 9

MEMORIES FROM DYERSVILLE

Located on the western edge of Dubuque County where the prairie meets the hills and valleys of the Driftless Region, Dyersville is the second-largest city in the county. Surrounded by rich soil and well watered by the Maquoketa River and its tributaries, Dyersville attracted settlers interested in farming rather than lead mining. While its economy has diversified, farming is still a major industry today.

As early as 1837, the Whiteside brothers, along with Henry Mouncey and others, selected claims in the area to be known as Dyersville. Thomas Riggs; Thomas Finn; Theopolus Crawford, who later was a member of the legislature; and Reverend William Trick, along with their families, soon joined them. Most of these early arrivals came from Somersetshire and Devonshire, England. At first, they preferred wooded lands as they provided logs for homes and fences and fuel for the cold winters. Only later were the open lands of the prairie seen as beneficial for farming.

Forty-two settlers arrived in carts pulled by oxen after a river journey up the Mississippi to Dubuque in 1846. James Dyer Jr., who was described by early historians as a man of means and leadership, came to the area in 1847, with other family members following in 1849. The community grew rapidly and by 1849 had acquired the name Dyersville.

In 1850, the residents considered moving the community several miles farther down the Maquoketa River. Despite the encouragement of James Dyer, the plan was abandoned. John Bailey, John Gould, Robert Whiting and others came to Dyersville during 1849–50. Many of these families had

first come to Dubuque from England to mine lead but moved west to pursue farming. In 1851, residents convened a meeting to have a survey done to lay out the design of the city. Homes, stores, a gristmill and a sawmill soon formed the beginnings of a prosperous enterprise. Crossing the Maquoketa River meant wading or, in higher water, using a boat. James Dyer alleviated that inconvenience when he built a bridge at a cost of $4,000.

In 1853, Orsemus L. Foote appeared in Dyersville with great flourish. He immediately bought half interest in the unfinished gristmill, finished it and began building Dyersville's first hotel. The two-story brick structure was built with imported materials by contractor Malvin Simpson, whom Foote had hired from Galena.

A post office established in 1854 added to the town's credibility. A Methodist church that same year, a Catholic church in 1858, Lutheran and Congregational churches in 1858 and the Episcopal congregation in 1875 provided spiritual guidance to the growing community.

One of the first responsibilities assumed by early settlers was education. Miss Hannah Martin began teaching in 1842. She was succeeded by Miss Anna Trick and Mrs. Baxter. By the 1850s, it was obvious that a more permanent solution to educating the next generation must be found. A solution to this dilemma was found when Room 10 of the new hotel built by Orsemus Foote became the new classroom, with Miss Elizabeth Foote as the teacher. Unfortunately, this opportunity was short lived. A cholera epidemic forced the school to close. Children had to be taught at home or not at all. Several private schools began, such as a coed academy opened by a Mrs. Douglas in 1857, but without adequate funds, these soon closed.

The State of Iowa had formed township schools that had proven to be successful in other parts of the state. Dyersville attempted to establish such a system, but not until 1872 was there any success with a school in the Clarendon Building. In 1875, township bonds paid for the construction of a school building that was divided into primary, intermediate and high departments employing three teachers. The three-story brick building cost $8,500. Six directors elected by the township residents provided the administration of the school system.

The advent of the railroad brought more opportunities for prosperity. The Iowa Pacific Railroad arrived in 1857. Hundreds came to see the train pull into the depot that was, in fact, the terminus for the line in 1857. Now connected to the Chicago markets, farmers could ship their livestock and grain to the east much easier. The railroads altered the shipping that had gone south using the Mississippi River. During 1880, Dyersville shipped eight

hundred to one thousand carloads of hogs and cattle to the Chicago market via the railroad. A short-lived railroad to New Vienna allowed the farmers to the north of Dyersville to ship their livestock and grain and allowed passengers to ride more comfortably to Dyersville, Dubuque and beyond. Forty teams and a large construction crew installed the tracks connecting New Vienna and Dyersville, but in only a year it ceased operation.

The Chicago Great Western Railroad once traveled through Dyersville on its way west. Today, its former path is the Heritage Bike Trail running between Dubuque and Dyersville along the scenic Little Maquoketa River Valley for much of its distance. Only the Chicago Central and Pacific Railroad now passes through Dyersville. There is no longer any passenger service.

By 1873, Dyersville organized as a town rather than a village, electing a common council for governance.

Stone Cottage

Situated in Commercial Park along old Highway 20, the John Christoph house illustrates the lifestyle of these early settlers. In 1846, Michael Christoph arrived from Bavaria to farm at the new settlement of Dyersville. After his death, son John built a stone house for his widowed mother. Mrs. Christoph, being a hardy pioneer, once walked from their farm to New Ulm, Minnesota, a distance of almost three hundred miles, to visit her daughter and newborn grandbaby.

The one-room home of Anna Barbara Christoph was moved to its present location after being saved from demolition in 2004. The cottage was disassembled stone by stone and transferred to Commercial Park. Once there, it was reassembled by stone mason John Wessels from Independence, Iowa. In a twist of fate, Mr. Wessels discovered that Anna Barbara was his great-great-grandmother.

Captain Hancock

Another early settler of Dyersville, Captain Alexander Hancock of Wedmore, England, is buried in Mount Hope Cemetery. Captain Hancock was the grandnephew of John Hancock, the first to sign the Declaration of Independence. As a ship's captain, Captain Hancock arranged to sail to Australia in search of gold aboard his ship *Elizabeth*. As the ship was being

Christoph Stone Cottage. *Author's collection.*

prepared to set sail, it was hit by a huge wave and washed on shore. During the several weeks needed to repair the ship, his wife, Caroline, and their children took a train to Wales to visit family. As the train entered a tunnel, it broke down, causing smoke to fill the tunnel and the train. Sadly, Caroline died after bursting a blood vessel due to coughing.

Captain Hancock continued his journey with his children, ages nine, seven and five. They lived in Sydney, Australia, for a year until he decided, in 1855, to move to Dyersville, where his brother Charles farmed. His daughter Caroline married Ernest Hall in 1865 on her Uncle Charles Hancock's farm.

The Hall family emigrated from England to America, leaving behind two of their sons—Ernest, age twelve, and Gillium, age ten—with their elder brother, who was training at Westminster Abbey. Ernest worked as an apprentice to a carpenter. He walked three miles each morning to work. Along these walks, he often met and talked with Charles Dickens. After three years, the family sent for the boys, who then embarked on an ocean voyage across the Atlantic, a railroad journey to Dubuque and then a horse and buggy ride to Dyersville.

While attending his first Fourth of July picnic, Ernest glimpsed Caroline Hancock. It was love at first sight.

That love had to wait, however. When he was eighteen, Ernest was plowing a field. The horses became unmanageable. In a fit of temper, Ernest drove them—plow and all—into the river. The horses, caught in their harnesses, drowned. He wrote a note to his mother apologizing for being a burden to the family, walked to Dubuque and then followed the railroad tracks to New Orleans. Once he reached Louisiana, he found a job on a plantation building chimneys for slave cabins. With tensions rising between the North and South, his presence angered his employer's neighbors. He decided to leave when those neighbors threatened him one day while his employer was absent. Only the intercession of his employer's wife and her dog saved him.

After securing fifteen dollars from a friend of his father's in New Orleans, Ernest headed north and home. Along the way, he was suspected as a Yankee spy and nearly lynched. After reaching home, he enlisted in the First Iowa Cavalry. Wounded, he was held in a Southern prison hospital. Finally, he was able to return to Dyersville, where he married Caroline Hancock. They left for Chicago soon after the wedding.

Their daughter Grace married Clarence Hemingway. On July 21, 1899, Ernest Hemingway was born in Oak Park, Illinois, in the house built by his grandfather Ernest.

A CASTLE

With the Iowa Pacific Railroad in town, optimism that the Illinois Central seemed to be on its way and the end of the cholera epidemic by 1857, Dyersville residents enthusiastically faced the future. The Clarendon Hotel, on the southeast corner of Water and Union Streets, opened with splendor and fanfare. Judge Dyer believed it would not be able to hold all the visitors traveling to Dyersville. Regrettably, the dream burst later that same year. The Panic or Depression of 1857 abruptly ended the economic boom. Embezzlement, which caused the collapse of the New York branch of the Ohio Life Insurance and Trust Company, triggered the panic. Soon, Britain removed its funds from American banks due to lack of confidence. When thirty thousand pounds of gold shipped from the San Francisco Mint to eastern banks went to the bottom of the sea with four hundred lives, all hope that the government could fund its paper money sank as well.

Grain prices plummeted, land prices that had been driven to artificial heights due to railroad speculation plunged and the Illinois Central fell into default. Dyersville's optimism ended. The economic depression continued until the Civil War, but there was a bright spot to all this gloom for Dyersville. Reverend W.H. Heu de Bourgh, a French Protestant, arrived from Canada during this discouraging time. He immediately began a successful collection campaign of pledges toward the erection of the Congregational church. While building and serving his congregation, he, his wife and their large family of five daughters and one son began construction of a parsonage on the four hundred acres they had purchased only two miles south of Dyersville.

The de Bourgh castle, modeled after a castle in England, and grounds hosted weddings amid its splendor. Finished in 1864 at a cost of $25,000, the stone castle built in the shape of a cross with thirty-inch-thick walls showcased broad piazzas, tall Gothic arched doors and serpentine walks throughout the grounds. A winding staircase to a steeple in the west wing commanded a beautiful view of the surrounding landscape. Inside the home, the rooms, each with a fireplace, were constructed with walnut paneling from Andrew Krapfl's lumberyard. The home contained two rooms of forty feet in length. A chapel with stained-glass windows served not only for the family's meditation but also as the location for many weddings. Visitors to the splendid home arrived via private coach from the railway depot and enjoyed superb hospitality. Sunset Farm, as the estate was known, also possessed a large stone barn and other outbuildings.

The family returned to Canada in 1875. Prior to leaving, Reverend de Bourgh deeded Sunset Farm to W.R.I. Hopkins of England, the brother of his son-in-law, in trust for his daughter and her children. John Castell Hopkins, de Bourgh's son in law, whom the *Dyersville Commercial* described as "impecunious from every dissipation and immorality of almost every description," had married the Reverend's daughter Phelia. He borrowed money on the property despite not owning it and then, after spending the money, abandoned the mortgage, his bills and the property. After many legal proceedings, Mr. and Mrs. John Kenneally Sr. bought the property. On June 12, 1903, a fire of unknown cause gutted the castle to its bare walls. Mr. and Mrs. Fred Strief lived there at the time. They escaped with a few furnishings, but all else went up in flames.

Protected by a fence, remnants of a foundation and crumbling limestone walls sit quietly amid a subdivision, but the Dyersville Historical Society hopes to open the site to the public at some point in the future. Those who

wish to see the castle can visit the Dyer-Botsford Museum in Dyersville, where a miniature of the castle built by Gib Nesler is on display. Mr. Nesler studied old newspaper pictures with a magnifying glass to construct as an exact replica of the castle as possible. After four hundred hours of labor, his creation provides visitors with a glimpse of this unique structure and its past.

Basilica

Between 1845 and 1865, more Catholic German farmers and Irish Catholic railroad workers moved into Dyersville. Unwilling to continue attending distant parishes, they organized St. Francis Xavier Parish under the direction of Reverend Andre Longfils in 1858. When Father Longfils left after only five months, St. Francis Xavier became a mission church of St. Boniface Parish of New Vienna.

St. Boniface had begun with its first Mass said by Bishop Mathias Loras on January 6, 1843, for the five German families who had settled there from Ohio. Members of St. Boniface provided homes and hopefully better lives for some of the orphans traveling west on the Orphan Trains from crowded eastern cities.

In 1862, the newly ordained Reverend Anton Kortenkamp arrived to serve the Dyersville parish. With his leadership, the brick church begun by Reverend Longfils was completed. It became rapidly obvious that the original church could not adequately house the growing congregation. Plans to build a Gothic-style cathedral with twin spires towering 212 feet with 14-foot-high crosses commenced. The building was completed in 1889. Unfortunately, Father Kortenkamp had died two months earlier. The new church seats 1,200 worshippers and possesses sixty-four large stained-glass windows. The rose window above the entrances replaced a traditional window in 1959. The new window depicts an Indian motif to honor those Indians who lived in Iowa prior to settlement.

Special trains brought people from all over Iowa to attend the dedication of St. Francis Xavier. The old brick church served as a school until it was replaced by a new building. Father Hoffman advanced the cause to elevate the church to the status of basilica. In 1947, German Cardinal Konrad von Preysing visited St. Francis Xavier Parish. Awed by both the building and members of the parish, he advocated for the elevation to the status of basilica. In the mid-1950s, the church was consecrated, thus meeting one of the requirements for becoming a basilica. Once consecrated, the building can never be used for any

St. Francis Xavier Basilica interior. *Author's collection.*

other purpose. A parish must also be debt free in order to advance to basilica. In 1956, through a papal brief, St. Francis Xavier of Dyersville became a basilica. It is one of fewer than one hundred basilicas in the United States. There are only two basilicas in Iowa, the other being in Des Moines.

BUTTER TUBS

William Raffauf emigrated from Coblenz, Germany, due to his opposition to militarism in 1854. From St. Louis, he traveled north on the Mississippi to Cassville, Wisconsin, in 1861. In Coblenz, he had learned the trade of cooper. A cooper (from the low German word *kuper*, meaning cask) made wooden staved vessels such as barrels, buckets and butter churns. In 1867, Raffauf moved to Dyersville, where he founded the Raffauf Butter Tub Factory, providing employment for twelve to fifteen of the town's residents. By 1891, the company produced 350 to 400 tubs each day. These tubs used by the many creameries in the region were made of white ash, spruce and basswood. He retired in 1892.

Martin Jaeger acquired the Butter Tub Factory upon the retirement of Raffauf. Jaeger also emigrated from Germany. He farmed north of Dyersville. He married Francis White of Worthington, Iowa, where they raised twelve children. In 1888, he moved into town. He had been making butter tubs on a small scale at his farm, so assuming ownership of the factory was a natural transition.

A fire destroyed the factory in 1899. Despite having no insurance, Jaeger rebuilt the facility. Manchester, Iowa officials in Delaware County attempted to persuade Jaeger to move his factory to their town, but rather than move, he decided to enlarge the factory in 1906. A steady growth of dairies in the area increased the need for butter tubs. By 1909, the Jaeger Butter Tub Factory was shipping nine railroad cars of butter tubs every two weeks.

To prevent another fire disaster, Jaeger and his sons built a larger fireproof factory with the most modern equipment available in 1920. Incidentally, the building housing the old factory burned to the ground in 1930. During World War II, the Jaeger Butter Tub Factory supplied the U.S. Army. With seventy-two employees, it operated twenty-four hours a day producing five thousand tubs each day.

After the war, paper cartons replaced butter tubs. With less and less need for its product, the company closed in 1950. The factory building was sold. Today, the building houses the Meyer Mechanical warehouse.

CIRCUS WAGONS

Butter tubs, Ernest Hemingway and stone cottages are not the only claims to fame to be found in Dyersville's past. Uncle Ike's Circus brought joy to

many children and adults. Isadore Tegeler was born in New Wine Township to Bernard and Theresa Tegeler. He married Alvina Schemmel in 1928, and they lived their lives in Dyersville. He worked for the County of Dubuque and Iowa Highway Department for thirty-five years, but his passion lay in another direction: entertainment.

Uncle Ike's Circus traveled to neighboring Iowa towns with its dog and pony show and circus wagons. They were a staple at horse shows, parades, fairs and other local celebrations. At one point, he even had a camel. The circus training grounds, located near the Maquoketa River, are now occupied by the Crop Services Building. In 1942, the circus sold the dogs, ponies and monkey to J.E. Eldridge of Michigan. Uncle Ike was not out of the entertainment business, however. He bought a kiddy swing and Ferris wheel that could be rented. In 1944, he added a miniature train to the ensemble. On June 5, 1944, happy riders enjoyed the train at the Dyersville Park for the first time.

Uncle Ike's circus wagons were built by Tegeler, with B.J. Pasker manufacturing the running gear. One of the wagons was a replica of the Curtis Candy Company wagon. Lou Vorwald of Dubuque painted this bright

Uncle Ike's Circus wagon. *Courtesy of Dyersville Historic Society.*

red wagon with its cream trim. Since parts were no longer available for such wagons, most of them had to be manufactured from scratch. The hubcaps were finally secured in Canada. The beautiful red wagon carried the queen of the Baseball Tournament in the 1953 parade. Uncle Ike's music wagon's organ came from Berlin, Germany, and Vice President Hubert Humphrey rode in Uncle Ike's fringed surrey.

Uncle Ike created Tegeler's Lake on their farm in 1961. Here visitors could enjoy camping, as well as water-skiing shows, pony rides and boat rides. Today, the lake provides fishing and lovely lakefront property for homeowners.

Uncle Ike died in 1973. A sale of all the equipment and animals followed. More than four hundred people came to bid on the items, including the circus wagons. Several were purchased by the Red Theater Complex in Las Vegas, Nevada. Happily, one of the wagons has returned to Dyersville. It is on display in the Dyersville Antique Mall and once again participates in city parades.

Farm Toys

Tourists traveling to Dyersville flock to the National Farm Toy Museum, which displays thirty thousand toy farm implements, including one of the largest collections of cast-iron toys. Started in 1986, the museum also sponsors the National Farm Toy Show bringing thousands to enjoy buying, selling, trading and viewing farm toys of the past and present.

Dyersville was the logical choice for the museum as it was the home of Fred Ertl, who arrived in the United States from Bavaria, Germany, in 1923. He worked in a foundry in Dubuque, but when the company went on strike, he refused to walk a picket line and lost his job. With a family to support, he quickly devised a way to make a living. Using their basement in Dubuque, the family built toy tractors. Ertl made sand molds of the tractors and then poured melted metal into the molds. The children assembled the toys, and his wife painted them. They sold them at fairs, in the Roshek Department Store in Dubuque and to implement dealers as promotions. By the time, he was called back to work, he was more successful with the toys than he ever could have imagined. A family business was born.

By 1947, the business had outgrown the family's basement, so a larger building on the west side of Dubuque became its new home. Growth continued, so in 1959, a larger state-of-the-art manufacturing building in Dyersville housed the Ertl Company. Constantly enlarging the line of toys

and maintaining quality control allowed the business to thrive in Dyersville. Ertl produced not only farm toys but also Thomas the Tank Engine, Star Wars, NASCAR and Looney Tunes toys. Is there a home existing without at least one of these? By 1973, children and adults in Australia, Europe, Japan, South Africa, Singapore, Canada and Hong Kong, as well as the United States, enjoyed Ertl toys. When Fred Ertl Sr. retired in 1968, he sold the business, which then merged with other companies to become RC2. By 1980, they were manufacturing one million items each year. In 1970, son Joe Ertl left the company and started Dyersville Die Cast, which was a tool and die manufacturer rather than a toy company. Another son, Fred Ertl Jr., continued to work for the company until his retirement in 1992.

In 1977, White Farm Equipment Company approached Joe Ertl with a request to manufacture a White 2-135 model tractor. The White Company did not want a mass-produced item but rather a highly detailed exact replica of its tractor. Ertl agreed and found himself back in the toy business. Scale Models, his new company, was born. It produces scale models, as well as pedal toy versions, of various tractor models.

Fred Ertl III began Die Cast Promotions in Dubuque in 1996. It manufactures highest-quality die-cast metal replicas of the products made by General Motors, Harley-Davidson, Ford, Daimler Chrysler and others. The toy legacy of Fred Ertl Sr. appears boundless.

WOOD CARVING

Another creative resident of Dyersville found his niche in woodcarving. Jack Becker farmed his entire life but found an artist's calling in his sculpting of wood. Other than working for a short time at Thompson's Furniture in North Carolina with Russian woodcarvers, Becker's skill was self-taught. Since his grandfather's uncle had been a woodcarver in Vienna, Austria, Becker believed hereditary ability may have come into play. His ability showed itself early, as he loved to draw as a child. His inspiration to carve these pictures in wood occurred on a visit to the Bily Clocks Museum in Spillville, Iowa.

The Jack Becker Museum, operated by his family in their 110-year-old barn located north of Dyersville, showcases his prolific abilities. One masterpiece is a clock made of maple. It stands eight feet tall with scenes from his favorite period in history, the Revolutionary War, carved on all four sides. Another example of his talent rests at St. Matthew Lutheran Church

Jack Becker's carving of St. Francis Xavier. *Author's collection.*

in Readlyn, Iowa. Becker carved a pair of praying hands known as *Hands of Hope* from a rough-cut chainsaw design by Jens Sagaard.

In 1986, the Vorwald family financed a statue of St. Francis Xavier to be given to St. Francis Xavier Basilica in Dyersville. It stands five feet tall greeting all worshippers in the north entryway of the church. Carved from a butternut tree found on the De Sotel farm near Garnavillo, Iowa, it took three months for Mr. Becker to complete.

The Becker family hosted the Northeast Iowa Wood Carvers' Day at their farm on Saturday, May 6, 1989. Carvers and visitors came from near and far to not only enjoy Becker's creations but also to learn from one another. Jack Becker died on February 12, 2003, but his talent lives on in each of his carvings.

FIELD OF DREAMS

Without a doubt, Dyersville's most recent claim to fame came on the heels of a movie: *Field of Dreams*, a film about baseball, Shoeless Joe Jackson and, most touchingly, fathers and sons. Starring Keven Costner, James Earl Jones, Burt Lancaster, Ray Liotta and Amy Madigan, the film was based on the book *Shoeless Joe* written by W.P. Kinsella. Released in 1989, the movie received an Academy Award nomination for best picture. What no one foresaw was the intense emotional reaction released by *Field of Dreams*.

"Is this heaven? No, it's Iowa" became the informal state slogan. "If you build it, they will come" now is a common saying in American vocabulary, despite the fact that the original quote is "If they build it, he will come." Fans of the movie and baseball continue to make the pilgrimage to the movie site on Lansing Road near Dyersville. Each summer the field used for the movie welcomes visitors to play ball. On special days, they can watch as the Ghost Players emerge from the cornfields just as they did in the film to play baseball.

Truly, "if you build it, they will come."

Chapter 10

CIVIL WAR, ECONOMIC PANICS AND LUMBER TO THE RESCUE

The Panic of 1857 brought ruin and despair to Dubuque despite the year's optimistic beginning. The Pacific Railroad had been completed to Earlville, Iowa, to the west. The celebration to mark the occasion held in Dyersville had been well attended by Dubuque residents, who enjoyed the western excursion. Tracks for the Illinois Central now reached Dunleith (East Dubuque, Illinois). The Dubuque city limits had been extended, new streets were constructed and Main Street even received a hard coating or, as it was then called, was "macadamized." The city's population grew so rapidly that three large school buildings housing six hundred pupils each had to be built, and property values soared. Such was the optimistic attitude when 1857 dawned. It did not endure.

Unable or unwilling to recognize the signs, Dubuque residents continued to hope for economic prosperity even though the flow of emigrants into the city had slowed considerably. Very few covered wagons journeyed through the Key City to the riches afforded them to the west. Fewer travelers occupied the available hotel rooms. Fewer buyers visited the land office to purchase lots in the city or farms in the country. Workers began to lose their jobs. According to the 1880 *History of Dubuque County*, a prominent city banker said of the Panic of 1857, "the bottom fell out, and everyone was left financially without even a fig-leaf."

The year 1859 brought some relief as railroads once again began construction, businesses cautiously expanded and migration increased but at a far slower rate than earlier. However, a far more threatening event lay on the horizon: the Civil War.

War meant an increased need for lead. Although fewer miners now worked the mine, prices were high and demand was steady, so profits exceeded $200,000. War also meant losing young men to the military. Dubuque contributed the first military company in the United States for service at the start of the Civil War. The Governor Greys, whose uniforms allowed them to be confused for Confederate soldiers, organized in Dubuque and were pledged by Iowa governor Samuel Kirkwood to President Buchanan even before the outbreak of war. They trained in Dubuque, funded by J.K. Graves, as well as others, and when called to duty on May 14, 1861, numbered ninety-four men. Their first battle at Wilson's Creek in Missouri left seven dead and thirty-six wounded. Their commander, Captain Francis Herron, became the Union army's youngest major general.

In 1885, the Governor Greys became a company of the National Guard. They later fought in the Spanish-American War, served on the Mexican border in 1916 and, in 1917, left for France and World War I. World War II saw the Greys in action again in 1941. Some of the men joined the Ranger Battalion, and others were assigned to the British military. For their exemplary service, they received the French Croix de Guerre and a distinguished unit citation.

The Jackson Guards, formed by German residents and commanded by Captain Frederick Gottschalk, headed to the Civil War in 1861 along with the Greys aboard the *Alhambra* steaming to Missouri. Unfortunately, they lost their first battle at Wilson's Creek with heavy causalities. The Jackson Guards, consisting almost totally of foreign-born Americans, suffered a 30 percent casualty rate.

Political factions in the traditionally Democrat Party–dominated Dubuque intensified with the Civil War. Those Democrats who favored a peaceful settlement with the South allowing slavery were called Peace Democrats or Copperheads. Dubuque supported Abraham Lincoln in neither the 1860 nor the 1864 elections. Senator George Wallace Jones and former governor Stephen Hempstead of Dubuque had sons fighting in the Confederate army. As was explained earlier, Jones and Jefferson Davis, president of the Confederate States of America, were lifelong friends.

The *Dubuque Times*, a Republican newspaper, and the *Dubuque Herald*, a Democrat newspaper, attacked each other in each issue. Charges of libel and treason flew between them. Dennis Mahoney, editor of the *Herald*, refused to support the war. His editorials urged peace with the South and condemned the Lincoln administration. On August 13, 1862, he was arrested and taken to Washington, D.C., where he was imprisoned in the Old Capital

jail until November 11. He ran for Congress from jail against Republican William Boyd Allison, also from Dubuque, and carried Dubuque by a 2–1 margin, but Allison won the election.

George Wallace Jones was also arrested based on letters he wrote to Jefferson Davis and his antiwar rhetoric. Charged with treason, he was kept in prison for nearly one hundred days. He returned to Dubuque and his retirement home on Fourteenth Street. Not until 1894 was his reputation restored when the Iowa House and Senate set aside April 4, 1894, in his honor. The

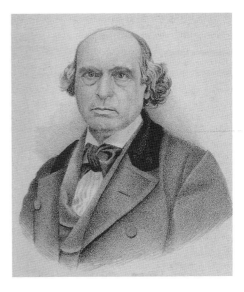

Dennis Mahoney. From the *1880 History of Dubuque County.*

Dubuque City Council followed suit. Congress voted to compensate him for debts he incurred as ambassador to Columbia and granted him a small pension of twenty dollars a month for his service in the Black Hawk War and as a drummer boy during the War of 1812. His home on Alta Vista Street had been used by the Visitation Sisters but was torn down in 1904 to accommodate an enlarged Visitation Academy. Later, the Jones Junior High School occupied the site. Today, it is the Alternative Learning Center on the Jones Campus of Keystone Area Education Agency. Controversy continued when the idea that the name of the institution should be changed because Jones once owned slaves surfaced briefly.

In early 1861, Camp Union, situated near the Mississippi River and Rhomberg Avenue, served as a recruitment and training center for the Ninth and Twelfth Iowa Volunteers Infantry. Six hundred volunteers under the command of Colonel William B. Allison lived there. It consisted of ten barracks, and Colonel J.K. Graves was the quartermaster. It closed in December due to antiwar sentiment and poor organization but was reopened the next year as Camp Franklin.

Camp Franklin housed 1,700 members of the Twenty-first, Twenty-seventh, Thirty-second and Thirty-eighth Regiments. The Twenty-first Regiment consisted of Dubuquers. To care for the sick when typhoid and measles epidemics threatened, J.K. Graves built a hospital. The Dubuque

Women's Society provided voluntary aid for the sick while the hospital was operated by the Sisters of Charity BVM. The Women's Society was organized by Mrs. Julia Langworthy, Mrs. Henry L. Stout and Mrs. J.W. Taylor. They not only administered to the sick but also made uniforms and knitted socks and bandages.

The camp was closed by Governor Kirkwood after he toured the location. Complaints of patient treatment and unhealthy food plagued the camp. After dismantling the buildings, they were sold at auction in January 1863. After the hospital was torn down, Columbia Academy (later Loras College), a boarding school for young men, assumed its former location.

In another connection with the Civil War, Alexander Simplot, born in Dubuque in 1837, sketched scenes of the Civil War while he accompanied General U.S. Grant. His sketches can be viewed at the Center for Dubuque History at Loras College. He returned to Dubuque to live after becoming ill during the war.

William Parker worked at the Simpson smelting furnace near present-day Asbury, Iowa, as a young man. He later served in the Union army during the Civil War. After being captured, he was sent to Andersonville Prison in Georgia. When the war ended, he was released and walked home to Center Township, Dubuque County. Witnesses reported seeing what looked to be a skeleton walking up the road. It was William returning home.

In April 1865, the Civil War ended. Citizens of Dubuque dressed in patriotic colors to parade through the streets. Flags hung from every available pole. The bell at the First Congregation Church rang so loudly and long that it cracked. A fund drive began for a monument to the soldiers who did not come home. In 1893, Dubuque's tribute to those who sacrificed their lives in the Civil War was erected in Linwood Cemetery.

After the war, Dubuque continued to grow and prosper. The Dubuque-Dunleith (East Dubuque, Illinois) bridge and the city's waterworks were completed. City street railways expanded to most areas of the city to meet the growing population. The Dubuque, Chicago, Clinton and Minnesota Railroad added more transit availability for commerce, and river traffic increased as well.

The 1873 Panic began when Jay Cooke and Company, a prominent banking institution in the United States, failed that autumn. The bank had been the backer of the Northern Pacific Railroad. Other banks and businesses fell like so many dominoes after Cooke. The public tended to blame the Grant administration, but the causes were much broader and centered on the overextension of railroad building after the Civil War. In

Dubuque, the Merchants National Bank collapsed due to an embezzlement scheme of Richard Babbage. Its closure set off a panic in the city.

Other Dubuque banks struggled but managed to survive. The depression that followed the panic caused unemployment and triggered labor disputes in the future. Recovery by 1878 witnessed a return to prosperity for Dubuque and its environs. Trade in Dubuque for 1879 was double what it had been the year earlier. In 1879, 1,081 steamboats arrived in Dubuque with 12,400 passengers. The population of the city grew to 30,000. While the mines still produced, the expense increased due to the high water table that often flooded the mines. The lumber industry grew after the Civil War as the logs from northern Wisconsin were floated down the tributaries and into the Mississippi River toward the lumberyards in Dubuque.

Ingram, Kennedy and Day opened a sawmill in Dubuque along the river in 1876 and rapidly became the Standard Lumber Company, the largest lumber mill on the Mississippi. The company employed four hundred men, with another five hundred cutting trees to the north. Log rafts filled the Mississippi River, sometimes covering acres of water. Over cutting in the woods of northern Wisconsin and fire caused the decline of the lumber business. The most disastrous fires in Dubuque occurred on May 26 and 28, 1911. The loss of finished lumber led to the demise of the Standard Lumber Company. The fire also damaged the shot tower by burning out the entire wooden framework inside the tower.

Henry Stout, one of the most famous of the lumber barons, came to Dubuque from New Jersey in 1836. He made his first fortune in mining but quickly diversified. He became a partner in the Knapp-Stout Lumber Company, as well as president of Farley and Loetscher Manufacturing Company, member of the board of directors for the Dubuque Bridge Company and People's Saving Bank of Dubuque and vice-president of the Commercial National Savings Bank of Dubuque. His sons, Frank and James, followed in his footsteps.

Both sons worked for Knapp-Stout Lumber Company. Frank was also president of the Iowa Trust and Savings Bank, Star Electric Company and the Julien Hotel Company. James served as a Wisconsin state senator from 1895 to 1910. He founded the Wisconsin Training Center that later became Stout Institute and is now University of Wisconsin Stout. James also served on the University of Wisconsin Board of Regents for many years and was president of the Wisconsin Free Library Commission and of the Stout Lumber Company in Thornton, Arkansas.

Together with his son Frank, Henry Stout established the Highland Stock Farm and Nutwood Park. Nutwood Race Track and Fairgrounds opened in 1894 along Highway 52, John Deere Road and the railroad tracks. Thousands came to view the most famous horses in harness racing. Stalls rented for $1,160 a year. The most famous pacer of his day, Dan Patch, even raced at Nutwood. Dan Patch, an American Standardbred, never lost a race and broke all speed records fourteen times. Savage, Minnesota, is named for his owner, Marion Savage, who died only hours after the death of his beloved horse in 1916.

The park was named for Nutwood, a trotting stallion, that Frank bought in Kentucky. Since the horse was sixteen years old and not a famous racer, no one believed the purchase was a sound one. However, he was very successful and profitable in racing as well as standing at stud. Nutwood lived at Highland Stock Farm along today's Carter Road. This five-hundred-acre farm had both a covered quarter-mile race track and a half-mile track. Mares brought to the farm were bred to Nutwood for $1,000 each.

After Nutwood died, the Stouts sold all their horses and closed the farm. Frank Stout inherited the farm but spent most of his time away from Dubuque on business, so the farm was divided. His sister Fanny received the tracks, stables and stock barns. She had the outdoor track seeded and flooded the inside area to make a pond. Wild ducks and geese now swim where horses once trained. All the buildings and the covered track were dismantled. When Fanny died, the property was purchased by J.J. Nagel, who sold the land to the Sisters of Mercy. The Archdiocese of Dubuque later bought the property and constructed a new building facing the water. In 1951, Mount Saint Bernard Seminary opened at the location. In 1969, the Sisters of the Presentation took possession and renamed the property Mt. Loretto.

Frank Stout is also remembered for the construction of the Stout House on Locust Street and his donation of land for the Carnegie Stout Public Library across Eleventh Street from the house. The Stout House, built in 1890 in the Richardson Romanesque style, is today a private home after serving as the archbishop's residence for years. Each room on the main floor of the mansion was constructed of a different type of wood in an effort to entice potential customers of the lumber business to purchase their products.

Nestled on an island in Red Cedar Lake near Birchwood, Wisconsin, is another example of the Stout family's presence. Stout's Island Lodge,

Stout House. *Author's collection.*

constructed in 1903 on the main island in an Adirondack Camp style, provided relief from the summer heat for the Stout family and servants who had moved to Chicago from Dubuque. The lodge used carved beams imported from Germany. In 1912, the entire structure burned to the ground. Since leaving the bark on the original logs had been a mistake (bugs infested the logs), the new lodge used cedar logs bought in Idaho. This "Island of Happy Days" cost $1.5 million in 1915. Today that translates to almost $35 million. The lodge is listed on the National Register of Historic Places and serves as a vacation resort today. Frank Stout built the Big Farm on the mainland with several homes and two large barns capable of housing his herd of three hundred registered Guernsey cattle. Near Birchwood, he also built Tagalong Golf Course, which was modeled after the famous St. Andrew course in Scotland. Stout died in 1927 en route to his island paradise.

Fannie Stout, Henry's daughter, married Fred O'Donnell, an attorney. As a wedding gift, her father had another magnificent mansion built for

Dubuque Carnegie Stout Public Library. *Author's collection.*

A postcard of the Eleventh Street elevator, across from the Stout House and the Public Library. *Author's collection.*

Fanny Stout House. *Author's collection.*

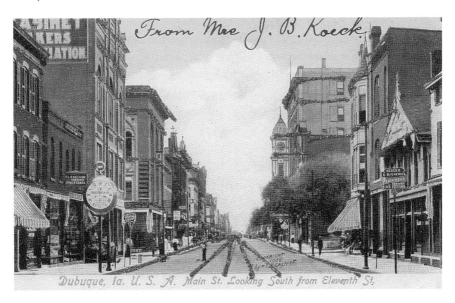

A 1908 postcard view of Dubuque's Main Street looking south from Eleventh Street.
Author's collection.

the newlyweds. The Fannie Stout House is on Locust Street next to the Stout House. After her death, the house became the Egelhof Funeral Home. Today, it is once again a private home with restoration ongoing.

The Civil War, economic boom and bust eras and the lumber industry moved Dubuque toward the twentieth century and more changes.

Chapter 11

A Cascade on the Maquoketa River

Located in the extreme southwest corner of Dubuque County on the Jackson and Jones County lines, the town of Cascade sits at falls that were once nine feet high on the Maquoketa River. With timber, good soil for agriculture and water power, the site was very desirable to early settlers. James Langworthy had explored the region as early as 1829, when the area was still legally Indian Territory. Nicholas Delong arrived in 1834 to break ground and plant corn. He returned the next year to plant wheat. His claim near the falls became home for his wife; five sons, William, John, Parley, Jacob and Perry; and his daughter, Susan. He soon sold a narrow strip of land adjoining the falls to John Sherman, who, along with his partner, Arthur Thomas, built the first flour mill in 1837. They also built the first hotel and store.

Meanwhile, the Delong brothers constructed the first sawmill several miles above the falls. The mill later became a paper mill and finally a flour mill called Myers Mill. The elder Delong had been a miner and for most of this time remained in Dubuque in search of lead. In 1841, Caleb Bucknam bought the claim from the Delongs. He platted the village of Cascade in 1842. The U.S. survey had been completed from 1836 to 1837. Alvin Burt, one of the surveyors, determined the meridian lines for Iowa. He later returned to live in Cascade since he had found it so attractive.

Chauncey Thomas was the first baby born in the village in 1838, while the first wedding happened between Susan Delong, who was only thirteen years old, and Jeremiah Reed. L.A. Styles taught the first school in 1840.

Since there was not yet a school building, lessons were held in a residence. Styles also became the first postmaster in 1842. W.W. Hamilton came to Cascade in 1842 as the first lawyer. He had also edited the *Dubuque Times*, as well as served in the state senate. Interestingly, the first temperance meeting occurred in Cascade in 1842 at the home of Arthur Thomas and was very well attended. With the gold rush in 1849, many of the American-born citizens of Cascade struck out for California, following the lure of gold.

The construction of the Old Military Road continues to be one of the most noteworthy events involving Cascade. The population of the region had grown exponentially from fifty in 1830 to forty-three thousand in 1840. Settlers were anxious to move into the western regions of the Black Hawk Purchase. Early roads were little more than muddy trails with no bridges over the many streams and creeks, so improved transportation was essential. To encourage Congress to appropriate money for such a project, the word "military" was added to the bill approving construction of the road, although most of the traffic was civilian. In 1839, Congress appropriated $20,000 for a military road between Dubuque and the Missouri border, including Iowa City and as many county seats as possible. R.C. Tilghman surveyed the route and hired Lyman Dillon, a resident of Cascade, to plow a furrow along the eighty-six miles from Iowa City to Dubuque. James and Edward Langworthy of Dubuque were contracted to build the road from Dubuque to the Cedar River. Lyman Dillon drove a team of oxen and a sod-breaking plow to accomplish his task. He received $3 a mile, used ten oxen and had his provisions in a covered wagon following the furrow. Today, the route is covered by Highway 151 from Dubuque to Anamosa and Highway 1 to Iowa City.

Lyman Dillon and his brother were orphaned at an early age. They lived in an orphanage, but Lyman was "put out" to work for a tavern owner. His work was hard and the hours long, leaving no time for schooling or books, so he ran away. He educated himself and was able to attend college in Utica, New York, where he was born in 1800. With the promise of excellent farmland and potential water power, he moved to Cascade. There he claimed land two miles north of the village on the north fork of the Maquoketa River and operated a sawmill. He was thirty-nine years old when he plowed the now famous furrow. He died in 1867 and is buried in Cascade.

Years later, in 1920, two enterprising Iowans retraced the route of Dillon and the Old Military Road. Marcus Hansen and John E. Briggs started from the steps of the Old Capital in Iowa City on a journey to Dubuque. They

remarked that many people had no knowledge of the old road, but they were entertained by those few who had memories. They passed through the once prosperous but now extinct village of Ivanhoe and the small town of Langworthy, located south of Monticello and named for the Langworthy brothers of Dubuque. After four days of walking, they finally reached the Julien Hotel in Dubuque with sore feet but a happy sense of accomplishment.

Cholera hit Cascade in the late 1840s and early 1850s. One victim of the disease, Mr. Phillips, left a wife and young son. They left Cascade in 1851 to accompany a group of Mormons west. After leaving Council Bluffs, Iowa, the group was attacked and killed by Indians. Only the son, Joel Phillips, and two young girls survived. They were adopted by the Indians. The girls married into the tribe and remained living with them. Joel—known as Joe—returned to Cascade in 1867. No one knew him, but finally his aunt recognized him from a childhood scar on his arm. He continued to live with the Indians, serving as a scout in the U.S. Army. Originally, he was sent to serve as a scout for George Custer, but his orders were changed so he avoided the massacre at Little Big Horn. He later worked with the Buffalo Bill Cody Show.

As in Dubuque, the Civil War brought division to Cascade between those who sympathized with the South and those who remained loyal to the Union. Thomas J. Chew, a Southern sympathizer, and his wife once harbored an escaped Confederate spy in their home. The Chew mansion, built of locally quarried limestone, resembled a Southern plantation. Mrs. Chew came from the Bemis family of Maryland, where they were friends of the Baell family. John Yates Baell sought refuge with the Chews after being wounded in an attempt to conduct terrorist attacks on the Union's northern border to demoralize the citizens of the North. Before arriving in Cascade, Baell and his men had attacked Union gunboats on the Rappahannock River, destroyed lighthouses along the Virginia coast and captured Union transports off the Atlantic Coast.

Mrs. Chew nursed Baell to health while he secluded himself in Cascade. His presence was known to only a few, and he spent his time reading a Bible given to him by Stonewall Jackson. After leaving Cascade, he became involved in a new plot to capture the Union war steamer *Michigan* on Lake Erie. Once the steamer was captured, the plan was to release three thousand Confederate officers held at Johnson's Island, a prisoner of war camp near Sandusky, Ohio, and proceed to Virginia, setting off panic in the Union. The plot failed when a stranger warned the commander of the *Michigan*. Captured three months later along the Niagara River near New York, Baell

was arrested and tried by a court-martial with General Fritz Warren of the First Iowa Volunteer Cavalry serving as president of the court. He was found guilty and hanged on February 24, 1865. The Chew mansion was eventually sold and became the East Cascade High School. It was demolished in the 1960s.

The year 1869 brought two divergent events to Cascade, but both were common to towns in the mid-nineteenth century. First, the paper mill burned. Fires in these early settlements was a constant threat given wood construction and oil lamps. Sawmills and paper mills were especially threatened due to their flammable products. Second, the temperance movement had arrived in Cascade much earlier, but by 1869, at least twenty-three locations in town sold liquor, reflecting the influx of German and Irish immigrants who opposed the temperance movement.

Bringing a railroad to Cascade had long been a dream. Since the 1840s, residents had been working to secure a rail line to connect Cascade to the eastern markets. All efforts had proven unsuccessful until 1878, when ground was broken for a narrow-gauge rail. Narrower than the four-foot, eight-and-a-half-inch width of standard rail lines, the less costly narrow-gauge lines usually served areas of difficult terrain or communities unable to justify the expense of a standard railroad. On January 1, 1880, the Cascade-Bellevue Narrow Gauge Railroad began service. This was a big year for Cascade as the village also incorporated in 1880.

The Cascade-Bellevue Narrow Gauge Railroad connected Cascade to the Mississippi River and the railroads located there. The road started at Bellevue, Iowa; followed Mill Creek for seven miles; and then continued up a steep 2.8 percent grade to La Motte, Iowa. The thirty-six-mile trip between Cascade and Bellevue averaged three hours. On February 22, 1907, train #103 derailed on a curved trestle at Washington Mills in Prairie Creek Township of Dubuque County. The rail cars fell forty feet to the ground below, killing three people and injuring seven. Local residents believed the railroad was not properly maintained and should become a full-scale railroad.

In 1915, the Iowa legislature appointed a commission to investigate narrow-gauge railways. The Bellevue–Cascade line was the only one in operation at the time. The commission discovered complaints on delay, breakage and poor handling of livestock. It recommended the change to a full-scale road but lacked any authority to order changes.

By 1931, the line had lost $66,000. Convinced the narrow gauge could not withstand the Great Depression, the Milwaukee Road, which owned the line, appealed to the Interstate Commerce Commission to allow the

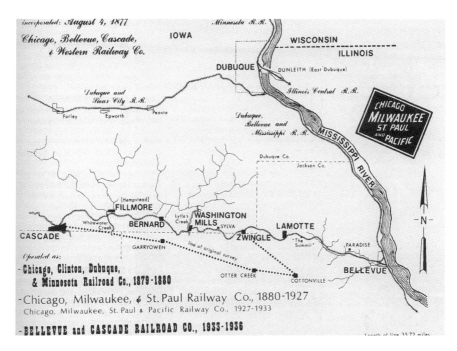

Map of the Cascade Bellevue Narrow Gauge Railroad. *Courtesy of Tri County Historic Society, Cascade, Iowa.*

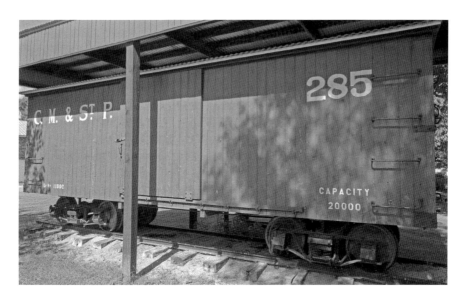

A narrow-gauge rail car in Cascade. *Author's collection.*

abandonment of the line. In order to keep the rail line running, the Bellevue-Cascade Company formed and bought the line from the Milwaukee Road. However, it was unable to make money on the line and defaulted on the loan from the Milwaukee Road. The Bellevue–Cascade line was sold for scrap in January 1936. The rails were removed in April 1936.

Cascade held its first fair in 1891. More than five thousand people attended, but warfare nearly erupted between Jones County—a dry county—and Cascade saloon owners. The problem was an Iowa law called the "five hundred yard law." This law allowed either county to prosecute offenders if a crime had been committed within five hundred yards of a county line. Since Jones County allowed no sale or consumption of alcoholic beverages, but Dubuque did, Cascade was literally "on the line." In 1897, Cascade was chosen as the site for the Dubuque County Fair. The star attraction was the famous race horse Dan Patch. The fair drew over six thousand visitors in one day.

Baseball quickly gained popularity in Cascade. As early as 1870, a rivalry already existed between Dyersville and Cascade when they played their first game. Born in Cascade on September 6, 1888, Urban Clarence "Red" Faber achieved great fame in the world of baseball and for his hometown. His father managed a tavern and Hotel Faber in Cascade. Since his family had achieved wealth, Red studied at preparatory academies in Prairie du Chien and Dubuque. By the age of sixteen, he was already earning two dollars a pitch for a baseball team in Dubuque. He pitched for St. Joseph's College (Loras College) in 1909, setting a school record for strikeouts in a nine-inning game when they defeated St. Ambrose University of Davenport.

Red Faber started in the minor leagues but quickly moved to the major league. His career spanned from 1914 to 1933 with the Chicago White Sox as a right-handed pitcher. He was the last legal spitball-throwing pitcher in the American League. During World War I, he served in the U.S. Navy. While in the navy, he lost considerable weight and injured his arm. Once out of the navy, he contracted the flu during the Spanish flu epidemic of 1918–19. As a result of these complications, he did not play in the infamous 1919 World Series against the Cincinnati Reds.

During the 1919 World Series, eight members of the White Sox team were accused of throwing the game for money from gamblers. All eight were subsequently acquitted at trial but were banned from baseball. Some players remarked that had Red Faber been present, the scandal would never have happened, such was the strength of his character and leadership.

The 1920s illustrated Faber's best and most successful years in baseball. From 1920 to 1931, he surrendered only ninety-one home runs—an average of only one run per month. He held the White Sox record for most games pitched and the record for career wins until Ted Lyons broke his record. After retirement, he coached the White Sox for three years. In retirement, he founded a charity, Baseball Anonymous, to assist those former sports players who were in financial trouble or suffering physical ailments. Named to the National Baseball Hall of Fame in 1964, he remained in Chicago with his wife, Francis, and son Urban II. Red Faber died in 1976 and is buried in the Acacia Park Cemetery in Chicago.

Cascade residents enjoy a unique pledge from Alfred Ringling of Ringling Brothers Circus. In 1880, much of his circus equipment was lost to a tornado in Onslow, Iowa. Since Cascade was said to be an excellent place for a successful circus performance, Alfred Ringling asked Mayor Isaac Baldwin for assistance. Mayor Baldwin then spoke with R.J. McVay, who provided private banking services for the community, as there was no bank in Cascade. Baldwin also edited Cascade's newspaper, so he used his facilities to print handbills for advertisements. Banker McVay extended the necessary finances for the circus to reequip. Cascade residents helped move the circus through the muddy roads to Cascade, distributing handbills along the way. On the day of the performance, the tent was packed, and that evening so many people came from the surrounding area that it was standing room only for the show. The proceeds from these performances allowed the circus to pay its debts and reestablish itself.

Since Cascade had no railroad and the Ringling Brothers Circus began to use the railroad to travel from city to city, the circus never returned to Cascade. However, during a show in Monticello, Iowa, Mr. Ringling spotted several Cascade residents and called them to the stage. He explained to the crowd how Cascade had saved the circus and announced that anyone who could prove he/she was from Cascade could attend the circus free anywhere in the world at any time. And so it is.

Chapter 12

TO DRINK OR NOT TO DRINK

D rinking has always been a part of the American landscape. By 1830, an estimated average of 3.9 gallons of alcohol was consumed per person in the United States. Those levels represent an all-time high for alcohol consumption in the United States.

With plentiful grain in the United States and transportation difficulties, whiskey converted from the grain offered an easier product to move from the farm to market. Since whiskey was cheap, it was a part of the normal diet for Americans. Added to water, it helped to kill germs present in the shallow city wells or river water that provided drinking water for the population. The usual routine for starting the day included an "eye opener" of whiskey, water, sugar and bitters.

Several groups—especially the Methodists and Quakers—denounced the use of alcohol on a religious basis. In 1826, Lyman Beecher, minister and co-founder of the American Temperance Society, wrote *Six Sermons on Intemperance* in which he claimed that any drinking was "irreclaimable" slavery to liquor. He believed that people could not know when moderate use of alcohol became drunkenness.

Temperance societies encouraged the "cold water cause," or drinking only cold water. There were songs, pledges, banners, speeches and many other methods meant to combat the abuses common to alcohol consumption. The word teetotaler means someone who practices total abstinence. By 1845, the temperance movement had an impact as the consumption rate had dropped by a gallon. In 1851, Maine became

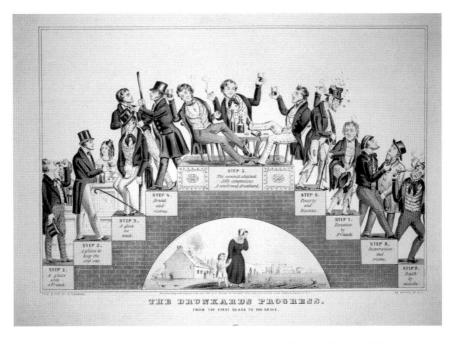

The Drunkard's Progress temperance poster by Nathaniel Currier. *Library of Congress.*

the first state to enact prohibition legislation. Then came the Civil War, followed by an increased influx of immigrants whose cultures included drinking beer, wine and other alcoholic drinks.

Temperance never had a strong following in Dubuque County. While some areas sponsored temperance societies, the German and Irish immigrants' culture that dominated the area was unsympathetic. In the city of Dubuque, several temperance groups did exist with small memberships. The Tribe of Jonathan #1 resulted from a meeting held at city hall in January 1877 directed by W.H. Curtiss, a lawyer and temperance advocate from Waterloo. At that meeting, 140 brothers, as they called themselves, signed a pledge to organize a temperance group. They elected J.L. McCreery as president, E.M. Newcomb as vice-president, John D. Murphy as secretary and A.H. Stuart as treasurer. They held their weekly meetings at Kistler's Hall near the corner of Main and Ninth Streets. In conjunction, the Tribe of Jonathan Ladies' Aid Society organized in 1878 to administer works of charity for those "seeking reformation and restoration to the better walks of life."

On April 4, 1879, the Dubuque Temple of Honor #13 elected a board of directors, including A. Wolcott, E.R. Gay, C.B. Dorr and H. Bartlett. They met weekly in their hall on Main Street. The Evergreen Temple of

Honor #2 allowed both male and female members. Organized on October 4, 1879, its officers included Miss M. Greenhow, Mrs. J.N. Newcomb, J.J. Ehlers and Miss Rebecca Ogle. Meetings held every Friday at the Temple Hall on Main Street were described as "enthusiastic in the cause of cold water." Also meeting at the Temple Hall, the Refuge Lodge #207 organized on December 28, 1860. The group later changed its name to Friendship Lodge. Charter members included both men and women such as Sarah Yates, Unio E. Clark, Fannie Mattox and Millie M. Gates.

Despite the work of the temperance groups, breweries dotted the city and surrounding area. By 1869, the city of Dubuque claimed nine breweries with more outside the city.

Mathias Tschirgi of Switzerland immigrated to the United States in 1845. He arrived in Dubuque in 1846 and immediately began in the brewery business, first outside the city but later moving into the city. He constructed a brewery on Julien Avenue (now University Avenue). After selling the company, he formed Western Brewery with Jacob Schwind in 1854. By 1880, the brewery was producing three hundred barrels of beer per week. He married Kathrina Zollicoffer, also of Switzerland, whose father, George, was an early settler. Zollicoffer Lake north of Dubuque in Peru Township was a popular recreational spot until the lock and dam flooded the area.

At the corner of Couler (Central) and Eagle Point Avenues (Twenty-second Street), Anton Gehrig erected a brewery but died before its completion. Anton Heeb assumed ownership of the Dubuque Brewery and obtained supplies from St. Louis. He began production in the 1840s with a capacity of six barrels a day. With success came expansion in 1856 and 1860. More buildings on Couler Avenue included a two-story brick home, a three-story brewery and a four-story malt house. The brewery employed fourteen workers, produced seven hundred barrels every twenty-five days and shipped to Kansas, Nebraska, Colorado and the Northwest.

The Northern Brewery established by Adam Glab on the northern city limits employed ten men and produced five thousand barrels of beer each year. Glab's brewery contained a beer garden with trees, shrubbery, summer houses and flower gardens enjoyed by many visitors along with a bowling alley. The entire complex was located on the present site of the Holy Ghost Catholic Church and school grounds. Caves in the hillside used to cool the beer are still visible.

Titus Schmid, B. Scherr and F. Beck formed the Titus Schmid Company and operated the Iowa Brewery, also along Couler Avenue. A four-story brewery had the capacity of seven thousand barrels and also had a malt

house, dry kiln and fermenting and cooling vaults constructed of stone. A home added in 1857 originally of three stories was damaged by a tornado and subsequently lowered to two stories. In 1868 after Scherr's death, his wife purchased half interest from the surviving owners. In 1869, she sold her interest to Kiene and Rhomberg. In 1877, William Meuser bought their interest and, along with the Schmid heirs, continued production.

Heeb's Brewery merged with Glab Brothers Brewery, Schmid Brothers Brewery and Western Brewing Company forming the Dubuque Brewing and Malting Company in 1892. The company covered ten acres at Thirtieth and Jackson Streets. Designed by Louis Lehle of Chicago, the magnificent castle-like structure housing the brewery demonstrated the Romanesque architecture style and covered three acres. Considered the most modern facility in the country, it brewed 300,000 barrels of beer per year using the brands Export and Banquet. Before battery-driven vehicles delivered the beer, fifty teams of horses were stabled on the grounds to pull the beer wagons. Caves located throughout the city kept the beer cool until refrigeration replaced them. The company was the first in Iowa to install a bottling line. The Dubuque Brewing and Malting Company employed two hundred full-time workers with a value of annual beer production amounting to almost $1 million. A May 8, 1896 *Telegraph Herald* article covered the opening of the brewery. According to the article, thousands of spectators—including prominent visitors from New York, Chicago and St. Louis, as well as Mathias Tschirgi—listened to speeches praising the business, with the First Regiment Band to entertain. The impressive structure housing the brewery complex consisted of 3.5 million bricks and four thousand feet of cut stone, covered five and a half acres and reached five stories. Although designed by Louis Lehle, Frederick Heer of Dubuque supervised the construction.

In 1860, Kohl and Stackere established the Germania Brewery in Dyersville. Purchased by Gehringer and Nachtman in 1865 and sold to Nicholas and Peter Esch in 1869, the brewery contained a brick ice house, a malt room, a fermenting cellar and a stone dry kiln. In 1871, a new stone brewery building was constructed. On the corner of Main and Walnut Streets in Dyersville, the Henry Schemmel Brewery produced one thousand barrels each year.

Frank May established a brewery in Cascade in 1856. The brewery operated out of a log structure first built by William De Long. May increased the business to a four-story stone brewery with a malt cellar, fermenting room, ice cellar and cooling cellar hewn from rock with a lager beer vault

eighty-eight by eighteen by twelve and a half feet and twenty feet below ground. Production reached 2,500 barrels a year.

Mr. Peaslee established Peaslee's Ale Brewery on White Street in the city of Dubuque in 1866 with facilities to produce twenty-five barrels per year. He was an avid experimenter who worked to create a beverage both tasty and low on alcohol content. His complex process emphasized quality of grain, kiln drying the grain to remove all moisture and careful monitoring of the fermentation before being placed in barrels in the cooling cellar. His success required the purchase of additional accommodations. He had purchased the Continental at the corner of Fourth and Iowa Streets, which he had used formerly as a hotel. He converted the building into a brewery that manufactured five thousand barrels of ale annually with fifteen employees.

Just outside the city, the Key City Brewery was located along the southern route into the city on Southern Avenue. Ignatz Seeger manufactured a cream ale, porter and malt liquors until he sold his interest to Dubuque Joint Stock Beer Brewing Company, owned by Frank Brady, A. Gleed, A. Reichman, himself and others. They completed improvements and continued operation until 1873, when Ambrose Gleed leased the facility until it closed in 1876. In January 1878, John Pier purchased the brewery and all its equipment. He and his six employees began to brew ten barrels of beer daily to be sold in Dubuque and the surrounding area.

The Dubuque Star Brewing Company incorporated in 1898. Joseph Rhomberg, who designed the unique six-pointed star as its emblem, served as president. The company produced Gold Star and Silver Star beers. After 1909, it became an agent for Anheuser-Busch products as well. At first, the company owned its own taverns to encourage more sales, but this practice stopped due to antitrust laws. Joseph A. Rhomberg arrived in Dubuque in 1854 from Dornbirn, Vorarlberg, Austria. As a result of Rhomberg's contributions and influences, the city of Dornbirn is today Dubuque's sister city in his honor. A delegation from Dornbirn visited Dubuque in 2014.

After the Civil War, millions of emigrants from Germany, Ireland and Eastern Europe arrived in the United States. While they assimilated to the American culture, they also brought aspects of their native cultures with them. The temperance groups saw these new arrivals as a threat to their objectives. Although alcohol consumption did not assume the levels it had in 1830, it did increase.

Cities especially felt the effect of alcohol abuse. Skid rows, named after the wooden skid built in Seattle to slide timber downhill, developed where transients—many of whom were alcohol abusers—lived. Saloons began

serving food often heavily salted to encourage patrons to increase their drinking. The original purpose of bouncers was to eject those who opted to overeat, not those who over-imbibed alcoholic beverages.

The Woman's Christian Temperance Union, formed in 1873, advocated a sober and pure society. Its objectives included home protection to protect wives and children from the effects of men's drinking. By 1904, medical journals were warning that drinkers were incapable of driving "motor wagons." They concluded that only total abstainers should be allowed to drive.

The end result of the temperance movement in the United States occurred with the passage of the Eighteenth Amendment. On January 16, 1920, alcohol manufacture, sale and consumption became illegal. The "noble experiment," as President Herbert Hoover once called Prohibition, had begun.

Traffic on the bridge to East Dubuque snarled on the night of January 15, 1920, as residents of Dubuque traveled to East Dubuque for that last drink. Iowa had outlawed alcohol consumption in 1916 after several earlier attempts. In 1882, the Iowa legislature passed an amendment to the state constitution to outlaw the sale of alcohol beverages within the state. The State Supreme Court ruled that the legislature had not acted in accordance with the state Constitution and declared the amendment null and void. In 1893, the Iowa legislature passed the Mulct Law, which allowed each county to decide if it would be wet or dry, the former allowing alcohol and the latter prohibiting it. Dubuque remained a wet county until 1916.

During Prohibition, the Dubuque breweries closed, but rumors persisted that beer, carried out in milk cans, still flowed at the Dubuque Brewing and Malting Company. Legal consumption of alcoholic beverages may have ceased, but bootlegging or illegal manufacture of alcoholic beverages flourished. Templeton, Iowa, became famous for the production of Templeton Rye—or "the good stuff," as it was known in colloquial language. This whiskey gave the farmers of Carroll County some supplemental income and was said to be Al Capone's favorite.

Al Capone was born in New York but moved to Chicago, where he assumed leadership of the Chicago Outfit in 1920—the same year Prohibition began. Using both violent and nonviolent means, he quickly cornered the market on illegal alcohol sales. He organized an international bootlegging empire with hundreds of breweries, delivery trucks, sales people, speakeasies and bodyguards to protect that empire. With an annual income of more than $100 million each year, he could easily bribe his way to legal immunity.

During those times when living in Chicago proved to be undesirable, Capone traveled across the Mississippi River to Dubuque. The many islands in the river also proved to be good hiding places for bootlegged liquor. While in Dubuque, Capone stayed at the Hotel Julien. There is some evidence that Capone's interests may have owned the hotel at one time. No direct connection exists, but during a lawsuit against the Cooper family, who owned the hotel in 1927, they stated that they were not the actual owners but that "Chicago interests" held true ownership of the hotel. Former employee Iva Whitney said in a *Dubuque Telegraph Herald* article that she witnessed Capone and his entourage arriving and leaving. She also said that he checked the books while visiting. Today, the Hotel Julien offers the Capone Suite on the second floor, complete with a vault and vintage décor for those who wish to experience a vestige of the Dubuque/Capone connection.

Another Dubuque County connection to Capone during Prohibition centers on the once lead-rich area of Durango. A remote farm near the village possessed an artesian well to provide a continuous source of fresh water to produce a quality—although illegal—product. When the barn exploded into flames one night, neighbors hurried to the site but were turned back by armed guards. The story has always been that when alerted that federal agents had discovered the location, Capone's employees destroyed the evidence.

When Prohibition ended on April 13, 1933, most of the breweries in Dubuque failed to reopen. Joseph Marko and M.L. Blumenthal purchased the Dubuque Brewing and Malting Company on Jackson Street in 1934. They invested $100,000 to remodel the plant, but the brewery never reopened. The would-be Julien Dubuque Brewing Company served as a storage location for Dubuque Packing Company's hams. In later years, the buildings housed the H&W Motor Express Company. In 2005, an effort to demolish the building ended when the city placed it in a Conservation District. Today, the massive structure houses Krueger's Auto and Truck Parts. When interviewed by the *Sioux City Journal* on May 11, 2013, owner James Krueger emphasized that he is fixing the building as time and money allow. He said, "We have to preserve this building. There is a lot of history here."

Dubuque Star Brewery reopened with the demise of Prohibition under the direction of Alphons Rhomberg, Joseph W. Rhomberg and J. Anthony Rhomberg. Sales for Star Beer reached a peak in the 1950s, when it produced fifty thousand barrels a year with forty employees. With little modernization, the brewery declined so that by 1971 only twenty-five thousand barrels were

brewed. At that point, the Rhomberg family sold the brewery to Joseph S. Pickett. The new company, Joseph S. Pickett and Sons, increased production and sales to eighty thousand barrels annually with a massive renovation and modernization effort. Pickett's Premium Beer was its premier product. The 1978 movie *F.I.S.T.* with Sylvester Stallone, Rod Steiger, Melinda Dillon and Peter Boyle featured the tasting room of the brewery.

In 1980, Pickett formed a partnership with Agri Industries. The next year, Pickett sold his interest to Agri, which then restored the name to Dubuque Star Brewery. It produced Rhomberg beer until 1985. In 1981, the movie industry once again used the brewery in *Take This Job and Shove It* with Robert Hays, Art Carney and Barbara Hershey. After several failed attempts to reinvigorate the brand and brewery, it closed in 1999. The City of Dubuque acquired the property under eminent domain. In 2006, Stone Cliff Winery began operation of its facilities within the historic structure. A river walk in front of the brewery follows the flood wall along the Mississippi, and an amphitheater often showcases live music nearby for the enjoyment of locals and tourists alike.

Today, microbreweries, wineries and distilleries are flourishing as a continuation of Dubuque County's long brewing history.

Chapter 13

WHERE? WHO? WHAT?

In the twenty-first century, we look around us for reminders of our history. We find those reminders in books, photos, reminiscences and landmarks. As the years pass, so do those landmarks of once flourishing businesses, homes and villages. Let us remember some of them here.

Located along Highway 20 and the Chicago Central and Pacific Railroad tracks, Peosta houses Northeast Iowa Community College, many businesses and a thriving residential community. When the village was platted in 1855 by Simeon and Sarah Clarke and Elisha and Angeline Brady, its name was Caledonia. Problems surfaced immediately because the founders believed the site to be the future intersection of the Dubuque and Sioux City and South Western Railroads. Farley to the west was chosen instead, and this, along with the Panic of 1857, caused the investors in Caledonia to lose their money. Caledonia became Peosta when the original investment failed. The name honored an Indian said to have been a friend of Julien Dubuque.

A house built near the railroad tracks by Simeon Clarke became a store and a place of worship for Methodists until they had their own church building. A hotel added in 1857 never realized the visitors predicted and was removed to Farley. Both Methodist and Campbellite churches were built in 1857. Campbellite is a pejorative label for Christian churches evolving out of the restoration movement in the United States during the nineteenth century. Thomas and Alexander Campbell preached a restoration of the early Christian worship practices. Their church in Peosta fell victim to a tornado in 1875. The Presbyterians worshipped in the Methodist church building

until they built a church in 1865. Catholics worshipped in nearby Centralia at St. John the Baptist, built in 1875 on ground donated by Peter Erschens. Contractor Adam Pott laid the rock foundation to the new church in 1874. Later, a brick schoolhouse and home were built for the Sisters of St. Francis. Reverend Hemsath arrived in 1887. He stayed for ten years, beautifying the grounds and frescoing the church with his own hands. In 1923, Archbishop James J. Keane ordered the parish to move to Peosta, where the railroad was expected to cause growth and more support for the church. The Sisters' and priest's houses were moved to a five-acre site. A new building combining the church and school was dedicated on December 3, 1924. The cemetery remained in Centralia. Removal of the church caused many hard feelings and led many Centralia Catholics to attend Mass in Lattnerville, Asbury or Epworth. A new church building in Peosta for the St. John the Baptist parish was completed in 1989. Due to declining memberships and fewer priests, St. John the Baptist combined with the parishes of Farley, Epworth, Placid and Bankston to form the St. Elizabeth Pastorate. The pastorate shares a pastor, deacons and staff members.

John Plumbe, the inventor of Plumbeotype, a process for producing lithographs from daguerreotypes, came to Dubuque from Wales as the prosecuting attorney for Dubuque County in 1836. He long advocated for the transcontinental railroad decades before its actual construction. He believed the government should grant land along the route of the railroad to foster construction. Plumbeolia, located in Concord Township of Dubuque County, never materialized, but Plumbe's brother Richard built his home at the location. Plumbe's Mills also never came to fruition. The lumber and gristmills Plumbe planned northwest of Rickardsville remained a dream. In 1855, the Pacific Railroad Surveys by the secretary of war proposed a nearly identical route to the one planned by Plumbe. He received no credit for the route or the idea. Despondent, he committed suicide at his brother's home in 1857.

Laudeville, named for Fred Laude, who operated a creamery with his sons near the intersection of Laudeville Road and Airview Drive, never incorporated. Once consisting of several homes, a blacksmith shop and a tavern, it has disappeared.

Sherrill's Mound or Sherrill's Mount is now known simply as Sherrill. Located in Jefferson Township, Sherrill was named for Isaac and Adam Sherrill, who were among the earliest pioneers in Dubuque County. Peter Fries, who came from Austria to Dubuque County, built a large stone inn at the crossroads in Sherrill. The inn was an extremely popular destination

for years. The first floor contained the bar, the second floor provided a dancing hall and the third floor contained six guest rooms. Often called "Little Niagara Falls" due to its popularity with newlyweds, it also had a beer garden with a pavilion for dancing. The Jesse James gang once stayed there on the way to the ill-fated Northfield, Minnesota bank robbery. When Fries died, the inn was sold. During Prohibition, the inn was converted into apartments. The building has been beautifully restored and now houses the Black Horse Inn.

Today, picnickers, sports participants and swimmers flock to Flora Park along Pennsylvania Avenue. Yesterday, however, Silver Acres occupied that location. Silver Acres also attracted many residents, but for very different reasons. Fancy trotting horses raced around the quarter-mile track built by Bart Molo. The track encircled a mound that allowed visitors to view the racers from all sides. The track provided stabling facilities for other owners, and its buildings held a variety of valuable antique sleighs and buggies. 4-H shows and horse shows also called Silver Acres home during the 1940s. In 1954, with a monetary gift from Harry Wahlert, chairman of the board at Dubuque Packing Company, the city purchased the property to create a recreational park and swimming pool. Flora Park is named in honor of Mr. Wahlert's wife, Flora.

The Hotel Julien has been the site of *The Bachelor* television show, a venue for the Julien Dubuque Independent Film Festival, the romantic setting for weddings and the festive location for many balls, parties and celebrations, but only once was it the site of a duel. In 1935, when a woman in Independence, Iowa, sought to follow the advice of her doctor to cure her blocked nasal passages, she sent for Limburger cheese from Monroe, Wisconsin. John Burkhard, the Monroe postmaster, sent the prescription, but Independence postmaster Warren Miller refused to deliver the foul-smelling package. He returned it. Burkhard re-mailed it. Miller refused to deliver it and returned it. Burkhard took his complaint against Miller to the United States postmaster in Washington, D.C., who agreed that the cheese was indeed foul smelling but not hazardous.

Postmaster Burkhard then issued the challenge of a duel to Postmaster Miller. The Julien Hotel in Dubuque hosted the confrontation. Reporters and spectators crowded the scene on March 8, 1935. Richard Davis of the *Milwaukee Journal* declared it to be a "battle to the breath." Limburger cheese is a relatively harmless hard cheese until bacteria is inserted to decompose the cheese into a creamy and definitely smelly cheese. Many believed it to be the best snack food to eat while drinking beer, so settling this dispute meant

paying homage to not only Wisconsin's cheese reputation but also its beer. Miller and Burkhard prepared for battle. Burkhard offered Miller a gas mask, but he refused it, saying that he had no sense of smell. Such a revelation shocked the spectators and the reporters. The duel fizzled. Burkhard won. Miller promised safe passage for Monroe's cheese throughout Iowa.

Inside the Ham House Museum in Dubuque resides a sword—not just any sword but one from Napoleon. The origin of this sword is the DeGriselles family of Centralia. Francis V. DeGriselles had lost his money in an effort to elect Louis Napoleon as president of the Second French Republic and in his subsequent tenure as emperor of the Second Empire. Hoping to recoup their losses in America, the family set sail. In 1854, the family arrived in Dubuque from France with a full complement of household staff, including their nanny, Julia Stroph, and their tutor, Edward Gonsalez. With the help of their friend George Wallace Jones, they settled on a farm near Centralia. However, Mr. DeGriselles spoke no English and was not a businessman, so while his family farmed, he stayed in Dubuque to teach French and painting at the Dubuque Female Seminary at the corner of Iowa and Seventeenth Streets. He boarded with the Mills family above their grocery on Sixth and White Streets. To repay them for their kindness, he later painted a picture of the Battle of Atlanta from detailed maps supplied by Mr. Mills, who had been at the battle. Mr. DeGriselles had actually been the son-in-law of General DeGriselles, who had transferred his royal title and name to his daughter's husband. The sword that had been awarded to General DeGriselles by Napoleon Bonaparte became part of that title transfer.

The eldest DeGriselles daughter, Mathilda, married George A. Shannon, a cousin of Senator Jones. Their two daughters, Genevieve and Josephine, survived to adulthood and lived on the family farm. When the new church for St. John the Baptist Parish was built in Peosta, Shannon Hall, which is used for parish and community events, was made possible by donations from the Shannon sisters. They also donated the sword and other family memorabilia to the Ham House.

At the intersection of Highway 52 North, Iowa 136 and Iowa Highway 3, where the prairie opens to the west, Luxemburg, Iowa, sits on the northwestern edge of Dubuque County. When the first settlers arrived to farm the fertile soil, they appreciated the beauty of the location and named the site Fleeburg, derived from the German word *floeten*, for the whistling sound the wind makes as it crosses the prairie. A post office opened there in 1860, and the name Allison was suggested for the village, but a popular vote

in the 1870s chose Luxemburg as the official name. The village was and is a rural community of hardworking farmers.

A statue of St. Isidore, the patron saint of farmers, stands in front of Holy Trinity Catholic Church in Luxemburg. The first frame church built in 1861 had no priest, so the members met on Sundays for prayers and the Rosary led by schoolmaster Anton Pfeffer. Originally, the bishop believed the location was too close to New Vienna and Holy Cross to warrant the construction of an additional church given the shortage of priests. The perseverance of the citizens resulted in the dedication of the church in 1865 with a priest to serve the parish as a mission church from Guttenberg, Iowa. The parish built a new brick church in 1875 and used the former church building as a school. As well as a post office, Luxemburg had carpentry and masonry shops; the Luxemburg bank; Schroeder's General Store, built in 1860 and now Ungs Shopping Center; Ungs Creamery; and Goebel's Blacksmith Shop. A controversy erupted between Clem Schroeder and Pastor Oberbroeckling because, rather than attending vespers at 3:00 p.m. on Sunday afternoons, Schroeder opened a bowling alley for patrons who also didn't attend vespers.

Luxemburg was gifted with a memorial sculpture of the Allied Liberation of the Grand Duchy of Luxembourg by the people of Luxembourg on the fiftieth anniversary of its liberation during World War

Antoine Loire. From the *1880 History of Dubuque County*.

II. It is proudly displayed by the village to remind all of the great sacrifices made during that war.

Lore, named for early settler Antoine Loire, was once located in Center Township near the present site of Sundown Ski Resort. Lore consisted of a post office from 1885 to 1897, a blacksmith shop, a school, a store and a saloon. The first known proprietor of the Eight Mile House, as the store and saloon were known, was L. Schmidt, but the most well-known owner was Ferdinand Fettgather. With the stage road running in front of the establishment, it offered food and respite for weary travelers and a stable for their horses. According to locals and visitors from Dubuque who traveled the eight miles for chicken suppers and

parties, the Fettgathers offered a "good pumpkin pie and pitcher of cream." The store burned in 1924 and was never rebuilt. Today, only scattered rocks from the foundation of a once prosperous business remain, while the blacksmith shop has been converted to a garage, the stable to a hay barn and the school to a private residence.

Near Lore, farther along Asbury Road to the west, nothing remains of a once bustling picnic grounds known as Twin Springs. The Chicago Great Western Railroad established a large site for celebrations on July 8, 1888. Excursion trains ran from Dubuque to this picturesque valley along the Little Maquoketa River. The early settlers held their picnics here for years. One of these picnics was attended by two thousand people, including Alphons Matthews, Dr. J.P. Quigley, T.J. Paisley and Andrew Bahl, all early settlers and distinguished citizens, as speakers. In 1908, Senator Allison spoke during the picnic. Flags adorned the grounds; a band played; food and beverage booths, including one from the Fettgather's Eight Mile House, vied for business; and children ran everywhere enjoying the games. The springs provided cool fresh water as relief from the heat. A dance floor added more enjoyment as a nickel allowed for the privilege of dancing once around the floor with a favorite partner to the latest music provided by a local band. Today, only echoes of once joyous voices remain as bicyclists quietly pass the Twin Springs intersection along Heritage Trail.

Twin Springs. *Author's collection.*

Ida Bahl, a descendant of Andrew Bahl, who came with his family to Dubuque County from Alsace, France, in 1845 and farmed near Lore, graduated from the Mercy Hospital School of Nursing in Dubuque. In 1934, she joined the U.S. Indian Service, where she served at a Navajo hospital at Fort Defiance, Arizona. She later worked in hospitals serving the needs of the Chickasaw and Choctaw in Oklahoma, the Chippewa and Pottawatomie in Wisconsin, the Sac and Fox in Iowa, the Acoma in New Mexico and the Hoopa in California. She wrote many articles for magazines and journals such as the *American Journal of Nursing*. In 1984, Bahl wrote *Nurse Among the Navajos* chronicling the six years she spent nursing on the Navajo reservation in Arizona. In the foreword of the book, Dr. Steven S. Spencer, medical director of the Navajo Nation Health Foundation, wrote, "It [*Nurse Among the Navajo*] is an important piece of history. It will be of interest to…all nurses, physicians…health professionals, and others concerned with Indian health and history."

Smelting furnaces once dotted the landscape in Dubuque County. All have disappeared. Burton's Furnace, located in Dubuque Township near Durango, processed hundreds of tons of lead from the Timber Diggings. Owned by John and Thomas Burton, the furnace began operation in 1835. Their residences, as well as others, occupied Burtonville. Thomas died in 1847. John continued the operation until his death in 1854, when his brother-in-law Richard Bonson worked the smelter.

Bonson's partner, Antoine Loire, purchased the original land patents for mining in the Cloie Branch stream valley, also in Dubuque Township. Richard Bonson, a successful early miner, built the family home in 1878 on Asbury Road. John Fern bought land from Valentine Glenat, who died of cholera on his way to California during the 1849 gold rush, in the Cloie Branch area. Nathan Simpson became his partner after returning from the California gold rush. Simpson married Bonson's daughter, Nancy. Together, Fern and Simpson operated Simpson's Smelting Furnace along what is today Hale's Mill Road.

This location was also the home to the Fizzle Cave Mine and St. John's Mine. The latter was owned by William St. John, who lived in Muscatine but had a temporary home at the mine site. Fern sold a parcel of land to Richard Spensley, who, like Fern, was from Swaledale in Yorkshire, England. Richard had married Alice Bonson, also the daughter of Richard Bonson. The Spensleys later moved to Vinegar Hill near Galena. When the price of lead fell dramatically in 1893, Simpson sold his holdings to Stephen Douglas Ryan, son of William

Ryan of meatpacking fame. The Simpsons moved to Dubuque and then to Minnesota. He died in 1903 and is buried in the Asbury Methodist Episcopal Cemetery in Asbury, Iowa. This long-gone lead booming area now is pastureland with scattered remnants and artifacts to remind the present generation of what once was.

Named for a grove of oak trees and the belief that it was in the center of the mining industry, Center Grove began in 1833, when miners followed the north branch of Catfish Creek in search of lead. The Jesse Yount family, Aaron Burr Alderson and Richard Bonson were among these earliest miners. The Daykin family arrived in 1845. Metcalf and John Daykin operated a store for many years, as well as the Three Mile House. Metcalf Daykin served as postmaster. Many of these early settlers came from Swaledale, England. These Yorkshire miners brought their talent for dry stone wall building technology to the Dubuque lead mines. Dry stone walls use no mortar. Their stability depends on interlocking stones.

From 1835 to 1855, more families from Yorkshire moved to Center Grove. These families were Methodists who originally worshipped at Rockdale, but as the population increased, the need for a church grew. The first Center Grove United Methodist Church, built in 1852, was a small structure without stained glass or other refinements. In 1886, the congregation built a larger brick church to serve the needs of the community. A monument for James Brunskill, who survived the Battle of Vicksburg during the Civil War, is located in the Center Grove United Methodist Church cemetery. James Brunskill, who was born in Swaledale, England, in 1841, came to Dubuque in 1849 and enlisted in the Union army in 1862. The church and cemetery are located on Brunskill Road just off Highway 20.

Edward C. Bartels built Bartels Cabin Camp along the Hawkeye Highway (Highway 20) to provide respite for travelers. He also bought the open-air dancing pavilion and replaced it with the Crystal Ballroom. Dancers enjoyed the best bands in the area through the 1940s. Today, the camping cabins are gone, the ballroom building has been converted to businesses and Center Grove itself is gone, having been annexed into Dubuque in 1973.

Born in 1910, Jack Jenny became a famous Dubuque musician. He played jazz on the trombone with Gene Krupa and Harry James in the Metronome All Star Band in 1940. He starred alongside Benny Goodman in the films *Stage Door Canteen* in 1943 and *Syncopation* in 1942. Jenny was born in Mason City, Iowa, but lived in Dubuque as he was growing up when his father taught at Columbia Academy (Loras). While in Dubuque, he played with Art Brown's

Novelty Band. He is best remembered for his rendition of "Stardust." He played with both the Artie Shaw and Glen Miller orchestras, and for a short time, he had his own orchestra. He served in the U.S. Navy during World War II and died in Los Angeles from complications of appendicitis.

A.A. Cooper built the Greystone as a showplace. It had thirty-five rooms on its four floors. Maple, cherry and mahogany wood decorated the interior. Cooper owned the Cooper Wagon Works, which covered twenty-seven acres in Dubuque and employed more than one thousand workers. The most popular wagon manufactured, "Old Reliable," led to sales of ten thousand wagons in Colorado and five thousand in Utah. Cooper claimed that using cured wood, a seven-year process, meant less cracking and warping and more reliability. His wagons reached an international clientele.

Cooper and his family occupied not only the Greystone but also the York House on the corner of Bluff and Sixth Streets and the Redstone at the corner of Bluff and Fifth Streets, across from the Greystone. His daughter Mary and her husband, John Waller, lived in the York House, while daughter Elizabeth and her husband, Daniel Sullivan, called the Redstone home. Between the houses, a smokestack rose from the heating plant that served all three homes. Additional buildings, including a carriage house, filled the remaining area.

Cooper, born in Pennsylvania, came to southeast Iowa with his family in 1841. At seventeen, he left home for St. Paul, Minnesota, but exited the steamboat at Dubuque to seek medical treatment for a wound suffered on board when a stray bullet from a drunken brawl hit him. In Dubuque, he apprenticed with a blacksmith. He was so successful that he owned Cooper Wagon Works by 1862. He served as a city alderman and as vice-president of the German Bank. Cooper knew each of his workers, toured his entire factory at least once a week and gifted each worker with a turkey at Christmas. He did not, however, believe the future belonged to the automobile. Despite overtures from the Studebakers and, according to popular legend, Henry Ford, he remained loyal to the wagon. Due to fire, no interest in continuing the business by his heirs and the waning use of the wagon, the Cooper Wagon Works declined. A.A. Cooper died in 1919, and his family eventually left Dubuque. The Wagon Works closed in 1920. In 1925, a fire destroyed the Cooper warehouse, and his sons decided to seek other business ventures, including owning the Julien Hotel in the 1930s. The Greystone was demolished in 1956 to make room for a parking lot, while the York House location was used for the new post office in the 1930s. Today, only the Redstone remains as the Redstone Inn and Suites.

Redstone Mansion. *Wikimedia Commons.*

On an interesting note, Cooper's daughter Regina married Paul Gilmore, a stage and silent film actor who at one time owned the Cherry Lane Theatre in New York City. Regina died two days after giving birth to twins in 1899. Gilmore gave custody of son Paul Jr. and daughter Regina to A.A. Cooper while he continued touring. Paul Jr. died jumping off a rail car on which he had hitched a ride. Regina, who lived with her father after reaching adult age, joined him in theatrical ventures and assumed the stage name of Virginia. Together, they later established Gilmore Comedy in Duluth, Minnesota. They returned to Dubuque after retirement, where Virginia died in 1981. Her father died while in Palm Springs, Florida, during the winter of 1962.

A short-lived narrow-gauge railroad once connected the village of Farley, Iowa, to the Red Rock Quarry to the north. Farley, located in Taylor Township, drew early settlers to its prime farmland. David Hogan, who emigrated from Virginia, explored the area in 1837 after leaving his wife and three sons in Durango. Being totally impressed with the potential, he returned for his family, built a log cabin and began clearing the land for

farming. Their supplies had to be brought by ox cart over land with no roads from Dubuque. Soon, others followed.

The gold rush of 1849 caused a disruption in Taylor Township, as it did elsewhere, as many followed the lure of fast riches to the gold fields of California. Few succeeded, and within several years, the settlers returned to farming. In 1851, Joseph G. Wilson arrived from Illinois to claim the land on which the village of Farley now stands. With talk of railroads moving west, Farley became the target of land speculators. In 1856, Wilson sold to the Iowa Land Development Company eighty acres on which the plat for the village was divided into lots. As a name for the village, the founders turned to a prominent Dubuque businessman, Jesse P. Farley, who was involved in both the Dubuque & Sioux City and the Dubuque & Southwestern Railroads coming through the town.

Wilson discovered the quarries to the north of Farley, purchased the twenty-six-acre property from William Comber for $100 in 1854 and began work immediately. He sold the property in 1866 to Robert Manson, John Douglas and Morris Brown, who quarried the site on a larger scale. Joseph and Ben Arcouit owned land adjoining the original quarry. They also quarried the rock, delivering one hundred rail cars of stone to Dubuque and beyond in 1880. The stone was described as yellow-gray in color, easily molded and a very attractive finish to buildings. The Blind Asylum at Independence, Iowa; the Custom House, Episcopal church, the steeple of St. Raphael's Church, Dubuque Senior High School and the bridge across the Mississippi River, all in Dubuque; and bank buildings at Waterloo, as well as many other bridges and buildings, were constructed from Farley stone.

The quarries to the north of Farley extended almost a half mile. The Red Rock Quarry yielded most of the rock used for the construction of the Hawkeye Highway (U.S. 20). The narrow-gauge railroad carried stone in hopper cars from the quarry south to the Chicago Great Western Railroad, where it was loaded into rail cars from elevated tracks and transported to the necessary construction sites. Donald Jeffrey supervised the building of the narrow-gauge railway while he worked as a contractor on the construction of the Hawkeye Highway from 1916 to 1919.

Many small communities possessed post offices in Dubuque County until either the mail was rerouted to a nearby town or the advent of free rural delivery about 1900 began delivery directly to homes. Some locations have retained their names, but many have totally disappeared. Derinane, located at the intersection of North Cascade Road and Sundown Road, operated a post office from 1857 to 1869. Ballyclough, named for a town in Ireland

from which many early settlers originated, had a post office from 1857 to 1900. The settlement no longer exists in Table Mound Township, but the name is remembered. Factoryville, overlapping both the Mosalem and Table Mound Township lines on either side of Lake Eleanor, was platted in 1855 but has also disappeared. Alma's post office in Taylor Township opened in 1855 but closed in 1857.

Cottage Hill in Concord Township once housed not only a post office from 1854 to 1907 but also churches, a school, homes and several businesses.

Thomas Hinde, a circuit rider preacher, served the Methodist church of Cottage Hill. He died after contracting pneumonia when he traveled to the home of member of the congregation to officiate at another church member's funeral. The congregation built a large frame church building to serve its members. Sydney Datisman, whose great-grandfather came to the region in 1836 from England, remembered attending the centennial service at the Methodist church as a child. When the church closed, the congregation moved to Rickardsville, while the church members in East Rickardsville transferred to Sherrill in the late 1940s. The church buildings were dismantled and the lumber recycled into houses and other structures. Today, the cemeteries at both Cottage Hill and East Rickardsville remain as silent reminders of those who came before us.

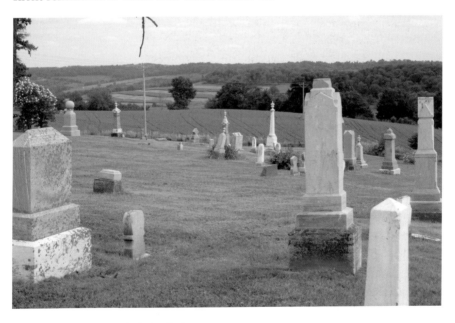

Cottage Hill Cemetery. *Author's collection.*

Cottage Hill Cemetery. *Author's collection.*

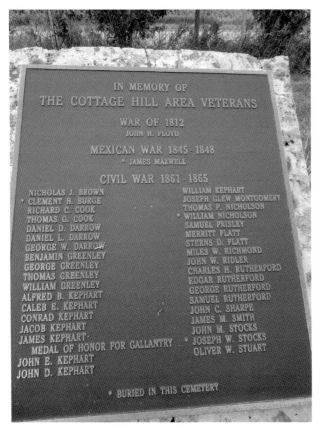

Cottage Hill veterans' plaque. *Author's collection.*

Evergreen, previously known as Tivola, offered a post office from 1854 to 1900, while Tivola had possessed a post office from 1849 to 1853. Located in Iowa Township, it no longer exists. A narrow-gauge railroad station, a post office and Sacred Heart Catholic Church called Fillmore home. Sometimes referred to as Hempstead, Fillmore had a post office from 1851 to 1903. Today, the church stands as testimony to the early settlers who brought their families to Dubuque County.

Not shown on any maps, Waubesopinecoux was listed as a post office in Dubuque County from 1838 to 1841. Another unknown location, Oakland had a post office from 1853 to 1859. Sheffield, in Cascade Township, kept a post office from 1869 to 1871, while Tara in White Water Township delivered the mail only from 1861 to 1865 during the Civil War. Glassnevin, in Liberty Township, had a post office from 1855 to 1859, and Hazel in White Water Township operated only one year in 1885. All of these communities have disappeared from the landscape.

In a rural northern area of Center Township, at the intersection of five roads, the village of the French Settlement once held a blacksmith shop, tavern, store, Catholic church, cemetery, school, post office and creamery. The original claimants of the land included Francis Bowert, Joseph Bowert, Isaac Foteau, J. Breau, Narcissus Foteau, J. Brow and Peter Bronett, all of French Canadian descent. These settlers disappeared from the area between 1850 and 1860. Many of these original settlers left Dubuque County in the 1850s, when the Dubuque Land Company attempted to resettle families in the Dakota Territory in a speculation scheme involving other investors from St. Paul, Minnesota. The investors desired to create a new territory with Sioux Falls as its capital and included the towns of Medary and Flandreau, with huge profits for themselves. The Indians who owned the territory drove them out of Medary and Flandreau.

In 1840, Bishop Loras offered Mass in a small log structure, officially known as St. Joseph Calasanctius but more commonly known as the French Settlement Church, built by the residents. Fathers Joseph Cretin and Victor Baden served as the first pastors at the settlement. To more closely accommodate the center of the parish's population, the log structure was replaced in 1860 by a large frame building in nearby Rickardsville on property purchased from Salmon and Elizabeth Rickard. St. Joseph Parish of Rickardsville was first served by priests from Holy Cross. In 1870, a new brick church and rectory was built. Bishop Hennessy sold the French Settlement church and grounds in 1891.

The La Page family remained in the village, now known as Five Points. Renowned for his talents playing the violin, Celiane La Page served as postmaster from his store for the year 1890–91. Joseph Farni managed a creamery as a cooperative. At first, local farmers delivered their cream to be made into butter. Later, a truck route collected the cream in metal milk cans from local farms to be transported to the creamery. Each can carried an identification number of its farm of origin so it could be returned and reused.

The one-room stone school building served the local children for nearly one hundred years. If fewer than ten children resided within the area, then the children traveled to the next nearest school. Due to competition from the Catholic school in Rickardsville, the school at Five Points closed periodically, sending its public school children to Cedar Ridge School two miles to the east. The county schools closed permanently in 1965, when students traveled by bus to either the Dubuque Community or Western Dubuque Districts.

The creamery closed in the 1950s. The tavern and store closed in 1974. Both buildings, as well as the school, were demolished. No trace of the blacksmith shop remains. When owners razed a barn on their property, they discovered a log structure inside the barn being demolished. It had probably been used as a barn or cabin during those early days of farming and had simply been built around. It, too, no longer exists. Today, only mysterious shadows linger in a hay field at the site of the French Settlement, possibly marking with uneven hay growth the foundations of former cabins and buildings.

There are many missing pieces to the puzzle that is history. Each and every one of us carries this history in our memories.

BIBLIOGRAPHY

BOOKS

Archdiocese of Dubuque, Iowa, 1837–2012: Jesus Alive through 175 Years. Strasbourg, France: Editions du Signe, 2011.

Bahl, Ida. *Nurse Among the Navajos.* Dubuque, IA: Sheperd Publishing, 1884.

Boge, Michael. *Union Park: A Place of Memories.* Dubuque, IA: Michael Boge, 1983.

Hawk, Black. *Life of Black Hawk, or Ma-ka-tai-me-she-kia-kiak.* New York: Penguin, 2008.

History of Dubuque County. Chicago: Western Historical Company, 1880.

Hoffmann, Reverend M.M. *Antique Dubuque.* Dubuque, IA: M.M. Hoffmann, 1930.

Lyon, Randolph. *Dubuque: The Encyclopedia.* Dubuque, IA: Union Hoermann Press, 1991.

Lyon, Randolph W., John Klauer, Dr. Gene Potts and Mike Gibson. *Faith and Fortunes: An Encyclopedia of Dubuque County.* Dubuque, IA: Flynn Printing and Graphics, 1998.

The Memoirs of Father Samuel Mazzuchelli OP. Chicago: Priory Press, n.d.

Rhomberg Pfohl, Rita. *Dubuque Nostalgia.* Dubuque, IA: Shepherd, Inc., 2009.

Wilkie, William E. *Dubuque on the Mississippi, 1788–1988.* Dubuque, IA: Loras College Press, Center for Dubuque History, 1987.

NEWSPAPERS

Cascade (IA) Pioneer.
Dubuque (IA) Daily Express Herald.
Dubuque (IA) Daily Miners Express.
Dubuque (IA) Miners Express.
Dubuque (IA) Telegraph Herald.
Dyersville (IA) Commercial.
Sioux City (IA) Journal.

MISCELLANEOUS

Baldwin, Howard C., and Helen G. Baldwin. *Cascade Centennial 1834–1934.*

Benedict, Rick. "Forgotten Iowa Cemetery Stops Condo Plan." http://dailyreporter.com/2009/09/22/forgotten-iowa-cemetery-stops-condo-plan.

Center for Dubuque History, Loras College with special recognition to Gerda Preston Hartman Collection and Frank Buol Collection.

Datisman Photo Collection. John and Lori Datisman, Durango, Iowa.

Fenn, Michael, Giller, Michael, Medic, Kristy J. Wapsi Valley Archaeology, Hales Mill Road Improvement Project. August 1914.

Hellert, Susan M. "Carry Us Forward." Paper for *Cross Currents in Women's & Gender History* hosted by the Women's and Gender Historians of the Midwest, June 2010. Dubuque, Iowa.

———. "History of Center Township." Master's thesis for Loras College, 1985.

http://iagenweb.org/dubuque.

Lillie, Robin M., and Jennifer E. Mack, et. al. Bio Archaeology and History of Dubuque's Third Street Cemetery, no. 13DB476, Dubuque County Iowa. Shirley J. Scherner, Principal Investigator, OSA Burials Program, in Research Papers, vol. 37, no. 1. Office of the State Archaeologist, University of Iowa, Iowa City, Iowa, 2013.

Palimpsest 4, no. 10 (October 1923): 346–57.

United States Census for Iowa, 1840–1940.

United States Census for South Dakota, 1860–1880.

www.ancestry.com.

www.iowaghosttowns.com.

Personal Interviews

Donald and Janet Schmitt
Gary and Sharon Childers
Robert Wilhelm
Sydney Datisman

A special thank-you to Judy Weber and the staff at the Dyersville Historical Society for their assistance.

About the Author

S usan Miller Hellert lives on the Miller Family Century Farm in Dubuque County. She is a retired senior lecturer in the History Department at the University of Wisconsin–Platteville. Always fascinated by local history, she has also written a local history column for the *Dubuque Telegraph Herald* and given talks and school programs to enhance residents' knowledge of local history.

The family farm includes a restored 1885 log cabin built by Susan's great-grandfather and a barn built of lumber from the dismantled roller coaster in Union Park of Dubuque County. She and her family raise a variety of animals for food and fiber. Spinning wool, weaving, knitting, gardening, horseback riding and reading occupy her free time.

Susan and her husband, George, share the farm and their time with daughters, sons-in-law and perfect grandchildren.